A *Celebration of* Caregiving

PORTRAITS & STORIES

Foreword by Lee Schulz

Independence*First*

The Resource For People With Disabilities

• Portraits by Lila Aryan, Francis Ford, Tom Olin & John Sibilski •
• Stories by John Hughes, Joe Shapiro, Mary-Liz Shaw & Crocker Stephenson •
• Edited by Jamakaya •

This book is dedicated to caregivers everywhere.

Their hard work and commitment

enhance millions of lives

every day.

Published and distributed in the United States by
Independence*First* Press
600 W. Virginia Street, 4th Floor, Milwaukee, WI 53204-1516
414.291.7520 (V/TTY)
www.independencefirst.org

Book Design by Hausch Design Agency, www.hauschdesign.com
Printed in the United States by Special Editions, Inc.

Table *of* Contents

Foreword
by Lee Schulz

An art. A profession.

A trial. A blessing.

A partnership. A journey.

A commitment.

The portraits in this book reflect the diverse experiences involved in the challenging and crucial role of caregiving.

Every day, millions of caregivers or personal care assistants – paid and unpaid – provide essential services for people with disabilities and those who are elderly or chronically ill. Every day, millions of individuals are able to maintain their independence outside of institutional settings due to the assistance of these unsung heroes.

We present these stories to highlight the critical role caregivers play in our families, our communities and our long term care system. We present them in the hope that the role of caregivers and the value of the work they perform will be better understood and appreciated by all.

In 2007, at least 47 million Americans engage in some level of caregiving activities for their family members or fellow citizens. Some of this work is compensated monetarily; most is not. Some caregivers receive professional training before they perform their tasks; most do the best they can on their own.

According to a 2004 study conducted by the National Alliance for Caregiving and the AARP, 44.4 million Americans engage in some level of unpaid caregiving activities for their family members or fellow citizens each year. Most of these caregivers are women (61%) who provide, on average, 21 hours of care per week. Three out of five caregivers surveyed indicated that they provided these services while also trying to maintain their own full- or part-time employment. The value of the work these caregivers provide to households nationwide is estimated to be $257 billion a year.

Another 2.5 million direct care workers – nursing assistants, home health aides and personal care attendants who are compensated for their work – also provide care to people with disabilities and those who are elderly or chronically ill. This type of paid caregiving in the home is often provided at substantially less cost than the alternative of institutionalized care.

The financial benefits of caregiving go beyond personnel costs, however. Caregiving – whether paid or unpaid – allows thousands of individuals to remain in their own homes and communities. This enables many care recipients to retain (or obtain) paid employment, ensuring their continued status as taxpaying citizens.

With the aging of the Baby Boom generation, America is expected to see a huge increase in its elderly population over the next few decades, putting increased stress on our health care system and creating an even greater demand for caregivers. The U.S. Bureau of Labor Statistics predicts that over 900,000 new direct care positions will be required by 2014. Caregiving, in many ways, is at a crossroads.

Will our country, our communities and health care industry provide the financial incentives – living wages and insurance coverage – that will attract new people into this line of work? Will we provide the type of training necessary to ensure the quality and effectiveness of personal care services? Can we devise a way to provide respite care or time off for caregivers so they can avoid burn-out? How can we ensure that people in more rural and isolated areas have access to caregivers?

The challenges are many and the time is short. We hope that "A Celebration of Caregiving" will encourage readers to think about these questions and become active with caregiving issues in their own communities.

Finally, please allow me to explain the terminology used in this book. We have included both unpaid family caregivers and paid workers in our stories, and we have used the term "caregiving" synonymously with all personal assistance services, whether paid or unpaid. As disability rights advocates at Independence*First* (an independent living center that works primarily with people with disabilities), we prefer to use the terms "personal assistant" or "personal care worker" regardless of who provides these necessary services. This preference is because the terms appear more

dignified to the care recipient. However, we have chosen to use "caregiving" in the title because it is currently more widely used and recognized by the general public, encompassing the elderly and chronically ill populations as well as people with disabilities. As time goes on, we hope the terms "personal assistant" or "personal care worker" will become more commonly used across all populations.

The stories in this book suggest that the keys for success in all caregiving situations are mutual respect, honesty and consideration between caregivers and care recipients. Please join us in celebrating these relationships and in working to elevate the caregiving profession.

Lee Schulz
Executive Director
Independence*First*

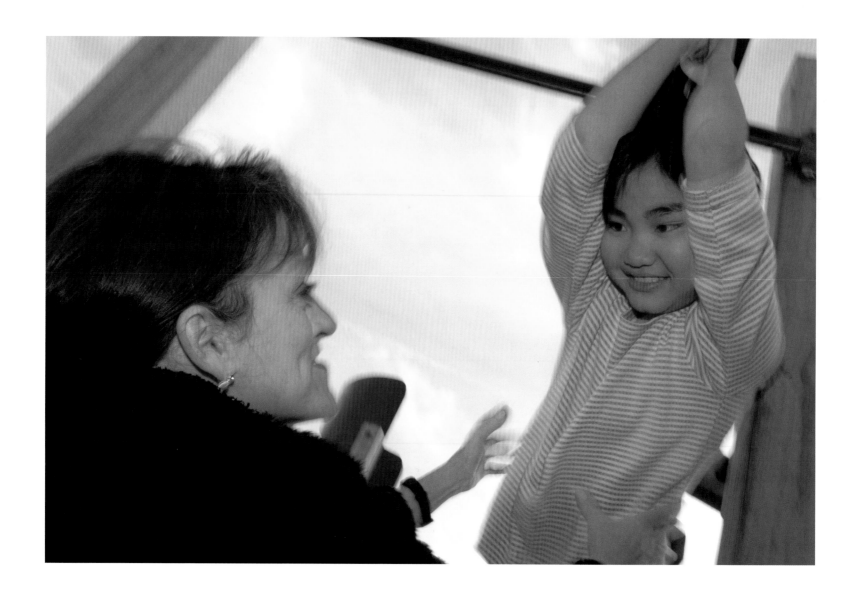

Linda & Kailee

There is Only Today

So, now what?

Linda Wells has been asking herself that lately.

For the past four years, Linda and her husband Owen have concentrated on getting their daughter, Kailee, well. At five, Kailee was diagnosed with severe aplastic anemia, a rare and often fatal disease that caused her to suffer complete bone marrow failure.

Linda twice went to China, where Kailee is from, to find a suitable donor. Kailee's first transplant, done in early 2005, was a long shot from a donor who didn't match key proteins. It failed.

Then Kailee's bouts of weakness and heavy nosebleeds grew more frequent. She required platelet transfusions every seven to ten days to fight infections.

In that state, "There is no future, there is no past, there is only today," Linda says. That is how you cope.

"Kailee is my soul mate and I think I am hers," Linda says, describing her steel-hard bond with her youngest child. "But at times it has been so ungodly painful."

Kailee expressed herself in art, including an unusual drawing of a mother rabbit cradling her baby. She spiced her daily journal with small tributes to Linda: "I ♥ my mom."

In November 2005, Kailee went through her second bone marrow transplant. This one took.

For Kailee, the transformation was simple and immediate. She could at last do what she was meant to do – be a kid.

For her mother, the downshift from perpetual crisis was harder.

"To me, it's like Hurricane Katrina," she says of her life, Post-Disease. "I look at the devastation – no job, no career, no money anymore."

So, now what?

Linda started as a nurse, and then studied law. She specialized in representing children in divorce cases. This gave her the gravitas to grapple with the frustrations of the medical system she encountered with Kailee.

Linda knows she can't go back to the law. It requires too much of your soul, she says, and hers belongs to Kailee now.

For a while, she will savor the peace of having nothing to do, reveling in days like Valentine's Day, when a healthy Kailee made her parents a delicious strawberry dessert of her own creation, served with a heaping scoop of pistachio ice cream.

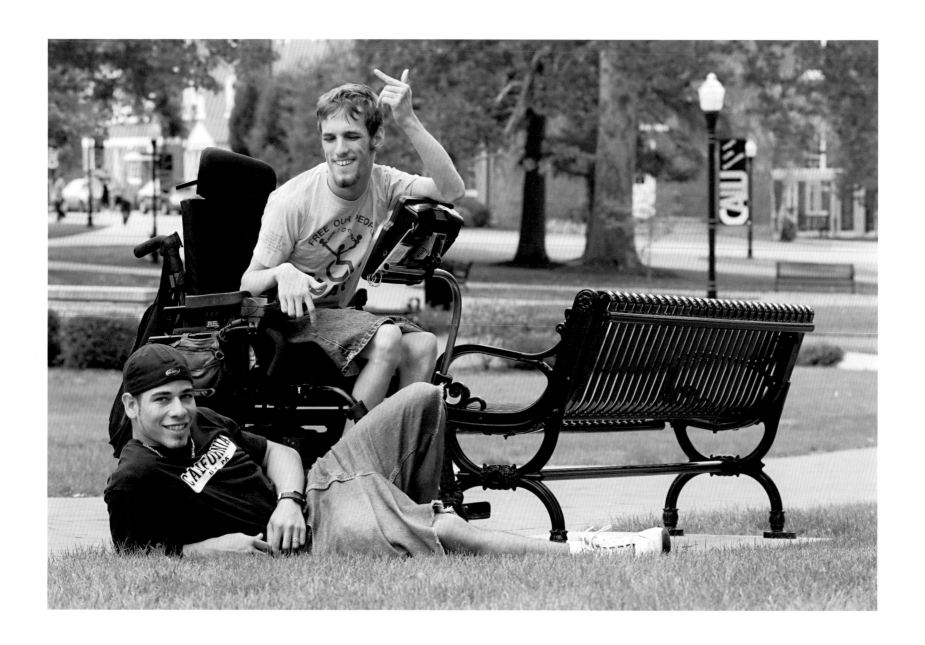

Aaron & Kyle
Like Brothers

It was freshmen move-in day at CalU, the California University of Pennsylvania, and, naturally, the dorm's elevators were broken.

Nineteen-year-old Aaron Spolter was taking a break from carting his possessions up the stairs when he noticed them: a father hefting his son's stuff – it always seems like too much when you're carrying it – followed by the son, who uses a wheelchair.

Aaron knew the inoperable elevators could turn the usual hassle of move-in day into an ordeal for the father and son. He is sensitive to such things. He has cared for his parents since he was 11. His mother has numerous health problems, his father has Parkinson's disease.

"I just went up to them right away and said, 'Do you need some help?'"

Aaron met the father, Jim Glozier, and his son, Kyle, then 18, again later in the school's offices. Aaron was looking for a job; Kyle was looking for a professional aide.

So began Aaron and Kyle's college journey together.

Aaron studies business finance; Kyle is a political science major. Aaron takes notes during all of Kyle's classes and helps him participate in class discussions. They eat lunch together, study with each other. At the dorm, Aaron helps Kyle shower and get ready for bed.

Kyle has cerebral palsy and uses a device called a Pathfinder to help him communicate. The keyboard, with its repertoire of symbols and letters, anticipates Kyle's thoughts by filling in common words or phrases from just a few key strokes.

The Pathfinder causes lengthy pauses and false starts (when the computer fills in the wrong word) in Kyle's speech pattern. Even so, it gives Kyle significant power to express himself, such as when he is asked what Aaron means to him.

"He is the same as a brother to me," he wrote.

The change from attendant to brotherly friend and mentor was both gradual and sudden, Aaron says. The two students had grown close, but when Aaron noticed Kyle's grades dropping, Aaron got permission to curb Kyle's TV privileges.

From then on, Aaron was watching over Kyle in a profound way, like a surrogate father.

He's a unique sort of surrogate – one who likes to take his "son" to the occasional frat party.

"You can't go to college and not party," Aaron says, with a chuckle. In the background, Kyle laughs loudly. "The memories are of partying, not of sitting in a class, listening to your professor. I wanted Kyle to have some memories."

Jesse & Chris

Opening Up

Jesse Hamberlin and Chris Rimmer have been living together for three years, and from the looks and sounds of it, they're having a blast.

Jesse is 56, looks 40, and has the free spirit of a man even younger than that. He's known Chris, 23, for fifteen years, because Jesse is the longtime boyfriend and current fiancé to Chris's aunt, Albertdean.

"He gets on my nerves sometimes," says Jesse of Chris, "like when I'm trying to cook and he gets up on me. But I'm crazy about him." Jesse smiles broadly and looks at Chris, who is covering his face with his arms and reciting rap words to himself.

"He gets his share of goin' out. His relatives are always coming by to take him out. They're crazy about him and I guess I'm nobody. But whenever he goes, I'm the first to ask for him, wanting to know when he'll be back. And while he's out, he starts agitating to get back to me."

Chris, who graduated from Special Education class at Milwaukee School of Languages, has been denied employment a few times in the ensuing five years. Jesse, whom Chris calls "Bubba," is employed part-time in custodial work. Therefore, especially during the long winter months, the two are cooped up in the house together. Albertdean works full-time, and the men in her life couldn't be happier with the situation.

Chris stands in the living room and asks his audience to listen to his rap recital. After a stanza, he dissolves into laughter, and says something a listener can't quite understand. With the ease of a deep connection, Jesse laughingly translates his words, "He says he wants some Budweiser."

Does Jesse give Chris beer?

"No way. But Chris is always speaking his mind. One time, we were at the church, and he kept breaking out with his rap singing when they were singing gospel music up front. Finally they finished, and he said so everyone could hear, 'Bout time they shut up with all that loud mess.'" Jesse and Chris both burst into hearty, ringing laughter.

The two share their time with video games, sports on television, walks to the store, and, in the summer, can smashing, gardening, and basketball in the neighborhood park.

"I've learned a lot from him," Jesse says with beaming pride. "He shows his true feelings, says what's on his mind. This opens me up. I've become a less guarded person because of Chris."

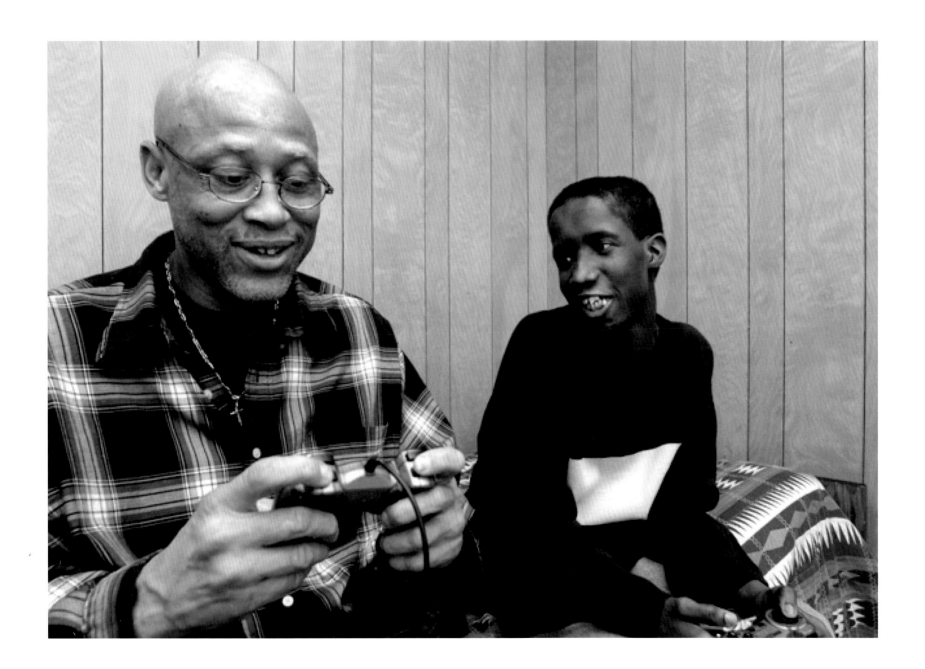

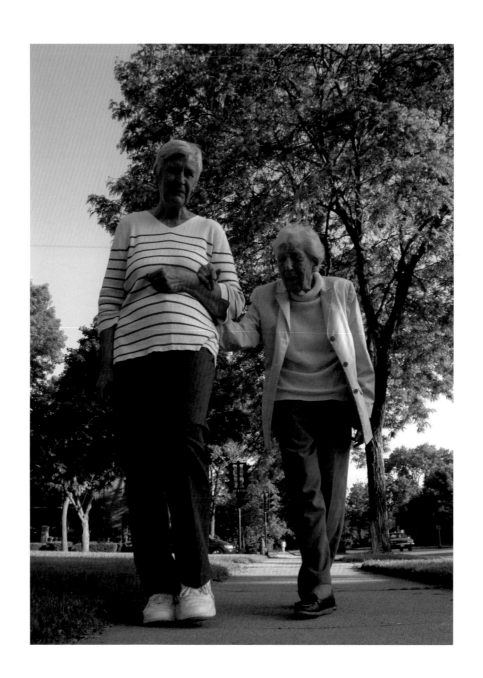

Anita & Josie

"*Making a Little Bit of Difference*"

Josie Kremers is 93 years old, and has lived in the same elegant apartment for over 40 years. As a person with Alzheimer's disease, she is unable to maintain a conversation, and recently asked a visitor five times about what his job is. Her temperament is serene, and she smiles often.

"I've been with her three years," says her caregiver, Anita Stanton, in a German accent. "Five days a week, 17 hours per day, beginning at 6 p.m. and lasting until 11 a.m. We're both German, and Germans have some good traits. We always want to be helpful. I recognize this in her attitude."

The disease is not mentioned in the household. Anita tactfully refers to "what we have here" when referring to Josie's condition. The two speak in German with one another, until Josie halts one conversation by using the Spanish phrase "Por favor," to Anita's delight. Anita is respectful, kind, and patient with her charge.

"I studied at the Aspen Institute of Humanistic Studies," Anita says. "It's like a health center. I learned how to do Swedish massage, physical therapy, and how to utilize sauna. From there, I moved to Alaska, then overseas, then to Cleveland, and started doing this sort of work when I cared for my husband's aunt for four years. She had what we have here. I've learned to care for people with Lou Gehrig's disease, multiple sclerosis, and what we have here. I get satisfaction in making a little bit of difference in people's lives."

"This is pleasant enough work," Anita continues, "except in the early evening, when we are visited by what is referred to as 'Sundown Syndrome.' This is when someone gets agitated, and paces briskly. They get agitated like a child. That's stressful. I have to be very patient. Watching television is bewildering for her, but we can settle her a bit with classical music. And a lot of repetition is required on this job. I have to repeatedly remind her that things were said already."

In her youth, Josie was a pioneer, earning her Bachelor's degree during the 1920's, when few women were doing so. Today, she listens to a conversation with a faint, uncomprehending smile. But she has warm company and a dedicated caregiver.

Frank & Scott
Oscar and Felix Revisited

Saturday morning, and Frank Zdanczewicz is fixing breakfast.

Six pieces of bacon. Three eggs. Coffee. Three pieces of toast.

"Four," says Scott Luber.

"Three. You can go in the kitchen and count them," Frank says.

"Usually it's four," Scott says.

Scott's already eaten. One egg. Salsa. Hot cocoa. Tomato juice.

Here is what Scott is wearing: an ironed Oxford cloth shirt, white, button-down. Olive corduroys, one-inch cuffs. Scott, who is a Certified Public Accountant, has a businessman's haircut that Frank's been trying to get him to change for years.

Frank, who has been Scott's live–in caregiver for 11 years, is wearing a white T-shirt. Fruit of the Loom. Frank's white shirt is a shade or two grayer than Scott's white shirt. Frank is wearing jeans, no belt. The top of his head is nearly shaved. His whiskers are not. He's got four piercings on his left ear, three on his right, one through his tongue, one through his nose, one through the skin between his lower lip and chin. He's got a couple of tattoos, if you care to see them.

When Frank interviewed for the job of caring for Scott, he smelled like cigarette smoke. Scott did not want to hire someone who smoked.

"You lied," Scott says.

"I did not," says Frank.

"You said you didn't smoke."

"It's not me. It's the cigarette that smokes."

"He's a chain smoker."

"I am not."

"You smoke a pack a day. More, sometimes."

"That's not chain smoking."

"It is."

Both men smile.

"We bicker about everything," Frank says.

"Not everything."

"Everything."

Again, they smile.

Eleven years, Frank has been Scott's caregiver. Almost a quarter of Scott's life. Almost of third of Frank's. Eleven years, Frank has been Oscar to Scott's Felix.

The thing about it, Scott says, is that he doesn't need his caregiver to be someone like himself. He needs someone who will take care. And that is what Frank has done these 11 years: Taken care.

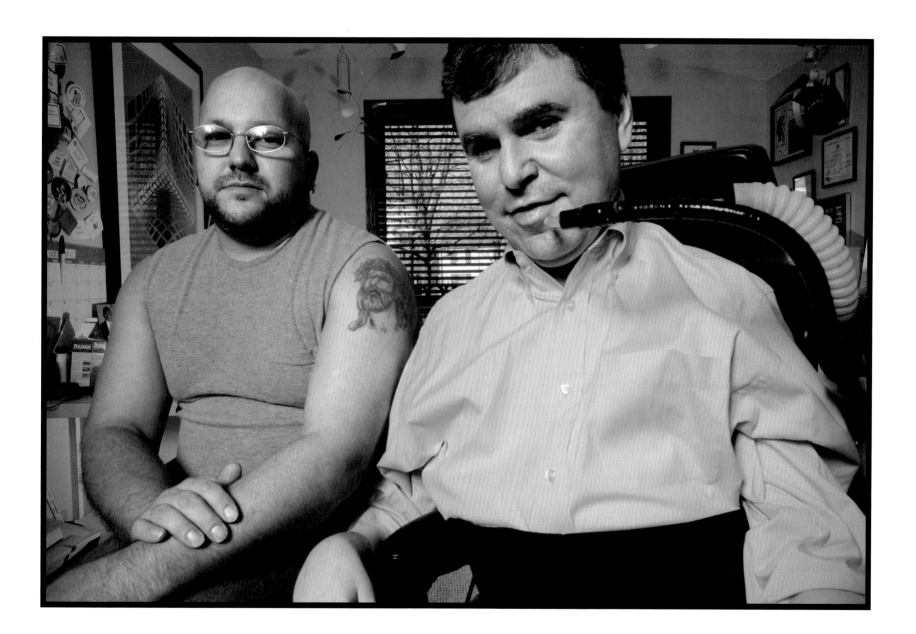

Anna & Lillian

Always Recognizable

That fall, a few months before Lillian Cohen turned 95, Anna Dobrakowska moved in, and the final chapter of Lillian's life began.

Anna arrived with a single suitcase, which she placed in the living room of Lillian's Chicago apartment. Lillian didn't know what to make of her new caregiver. Anna had blue eyes and yellow hair. She spoke with a Polish accent that was lush and exotic. Lillian called Anna "Honey." She wondered out loud if perhaps Anna wasn't too beautiful for the task at hand.

That first morning, when Anna brought Lillian her breakfast, Lillian asked: "Have you eaten?" Anna had not. She would eat after Lillian ate. But Lillian would not eat in front of someone who might be hungry. And so the two women ate breakfast together.

Anna's suitcase remained unpacked in Lillian's living room for nearly three weeks. Lillian's family worried that the suitcase meant Anna had not yet decided if she would stay. But no. It was simply that Anna was so busy – filling the cupboards with food, the apartment with flowers, Lillian's hours with companionship – that Anna hadn't taken the time to see to her own things. Anna would remain to the end of Lillian's life.

Time is the solvent that loosens all our attachments. In the years that followed Anna's arrival, Lillian began to forget. Her children and their children. Her history and the moments of her day. Where she was. Who she was.

"Am I dying?" Lillian would ask Anna. "Am I dying?"

But Lillian never forgot Anna. Anna remained, always, recognizable.

Anna combed her hair, helped her with her lipstick, and filled her purse with keys, make-up, a change purse and a wallet. She equipped Lillian for each new day, and spent the day near her side. It wasn't enough to merely care for Lillian; Anna sought to animate Lillian's life.

When Lillian's wedding ring could no longer remain on her finger, Anna placed her own ring in its place. Anna's ring lacked Lillian's jewels. It was a simple silver band, but Lillian, sensing the commitment it represented, loved it.

Three days after Lillian's 98th birthday – December 17, 2003 – Lillian's youngest daughter, Barbara, was visiting. Barbara was talking with Anna when, suddenly, Anna excused herself and went to Lillian's bedroom.

After a few minutes, Barbara followed. She found Anna kneeling beside Lillian's bed, her left arm under Lillian, holding her by the shoulders. Barbara knelt on the other side of the bed and took Lillian's hand. It was already cold. Lillian's breath was shallow.

Anna said to Lillian:

"You know, you always ask me when you might leave. It's all right now. Don't be afraid. You will be safe. This is the moment you can go to your home."

Lillian was buried wearing Anna's ring.

PHOTO: COURTESY OF THE FAMILY

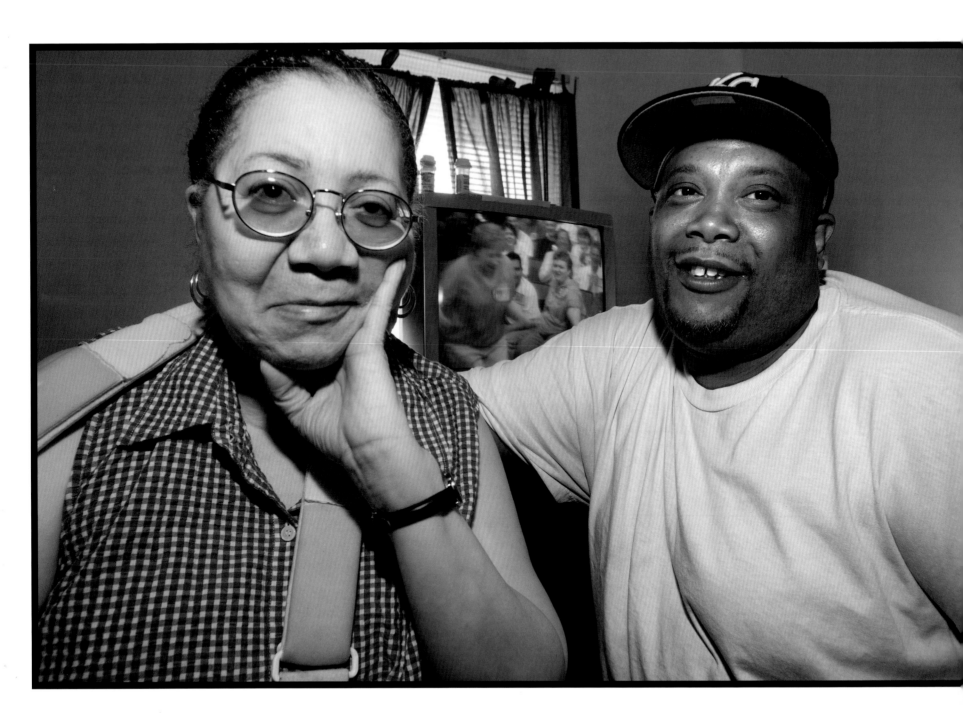

Antoine & His Mother

"Like a Full-Time Mom"

Antoine Drake grew up the eldest of nine children. As the big brother, he helped take care of his siblings, learning to cook, clean, wash and sew before he was ten years old. He learned responsibility, discipline, and compassion at the knee of his mother Sandra, who was an active person throughout her life.

This training has been called upon in the past few years in an unexpected way. In 2004, Sandra Drake was boarding a plane when she was debilitated by a stroke. She lost the use of the right side of her body, and her speech was greatly impaired.

After a sojourn in the hospital, Sandra wound up in a nursing home. Antoine hated visiting his mother in the hospital, because he hates them, but the nursing home was another thing entirely.

"My eyes got watery going in there," he recalls. "I hated it. It was painful. And I was always hearing other people, not just my mother, calling out that they didn't want to be there. Well, something told me, 'You got a house, you can take her in.' So I did. It's a blessed thing to do something like this. I don't mind doing it, that's for real."

Sandra is seated beside her son during an interview and has a difficult time responding to questions. She worked very hard to get one sentence out, and after a few minutes was able to say, "It's rewarding that I get to be home."

Antoine has an affable manner, and speaks passionately. "I have to cope with sadness," he says. "I'm used to seeing my mother getting up and going all the time. She was an active person, always involved at the church and helping with the babysitting. Now she's not."

He reports that his mother isn't the only person he cares for. Antoine's girlfriend has medical problems, so he is principal parent of his two boys, and takes care of the girlfriend also.

"A lot of people wouldn't do this," he says of caring for his mother. "I hear that all the time. But I'm doing something good. I'm like a full-time Mom around here, not only cooking, cleaning, and whatever, but also taking care of the pills."

When it's mentioned that a photographer will be coming to take pictures, Antoine says with a smile, "That's the day I get spiffy."

Sandra laughs affectionately at her son.

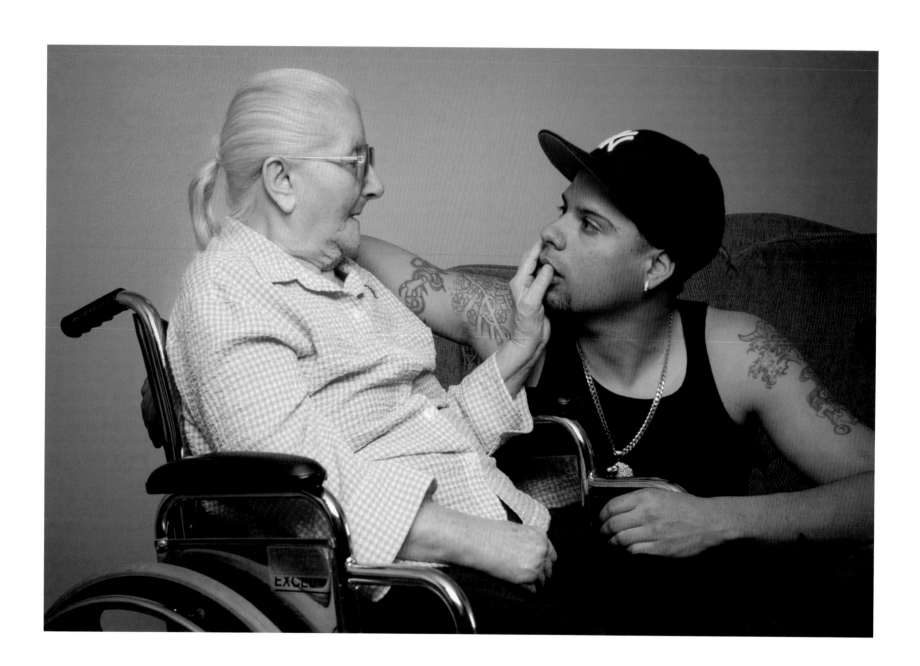

Carlos & His Grandma

"Don't Wait to the Last Minute to Show Your Love"

As a visitor approaches the apartment where Carlos Morales lives with his grandmother Dolores, his companion, Leslie, and three children, a drum machine is heard thumping on the other side of the door. The door opens, and it looks as though Carlos, 29, and his son Jeff have been playing the machine. Leslie sits quietly in one corner of the living room, and Dolores, a beautiful smile on her face, sits in a wheelchair in the opposite corner.

Dolores has Alzheimer's disease and also had a stroke. She lived in Chicago for 76 years, and stayed with her son in Texas briefly, until his struggle with emphysema precluded his caring for her. Dolores came to Milwaukee four years ago. She's been living with her grandson ever since. She is unable to speak.

"My uncle called me and said, 'Grandma is on the Greyhound, heading your way,'" Carlos relates. "That was fine. I had already made the decision to care for her. She arrived here with just a purse and her driver's license."

Carlos looks hip and youthful, with a large tattoo on his forearm, signifying "grace – gratitude to Jehovah," and silver earrings jutting out from beneath his winter hat. He has a serious, pleasant demeanor, and speaks with tremendous affection for Dolores.

"If you really love a person and appreciate what they've done in the past, don't wait to the last moment to show your love," he says, with Leslie nodding assent. "It's too late when they're dead."

Diana, daughter of Carlos and Leslie, walks in and sits beside her great grandmother. "I love to help," she says, placing a doll in Dolores's lap. "I make her laugh. I play with her."

"My grandmother's a baby now," Carlos says, without condescension. "She turns 80 in September, and she'd die if I didn't take care of her. We'd have to put her in a home if I didn't. But she raised me since I was a baby. Some of those nursing homes are cruel."

He glances at Leslie. "Also, all the appreciation I've got to give to Leslie. Another young woman would have given up. This is a hard responsibility. It's like double duty taking care of this home plus my grandmother."

Does Leslie have anything to say?

In a strong Puerto Rican accent, she says "Maybe Jehovah wanted me here."

Carol & Jack
Role Reversal

Carol Hartel takes care of her old friend, Jack Fooden.

Jack was in Vietnam in the mid-1960s. A marine, he was shot in the side, patched up and returned to combat. He finished his tour, and was waiting to leave the country when, during an enemy attack, he was – as he puts it – "blown up."

"I don't want to talk about it," he says.

"He has PTSD," Carol says. That's Post-Traumatic Stress Disorder.

"I don't think I have PTSD," Jack says.

"Yes, you do."

"I don't."

The physical legacy of Vietnam in Jack's life is spinal and brain injuries that, now that he's in his 60s, are growing worse. He's had more than a dozen heart attacks. He has diabetes and asthma.

The phone rings. Jack answers. He talks for a few minutes, then hands the phone to Carol.

"You do this," he says. "You got to make an appointment for me for Monday."

Jack has short-term and long-term memory loss. Carol is his memory. She remembers what he has done. She remembers what he needs to do next.

After Vietnam, Jack was in and out of prison. Jack figures he's done 30 years hard time. He says he spent 26 years riding with the Outlaws.

"I'm screwed up in the brain," he says.

Carol has three children. She has known Jack just about her entire life. The father of her children, Floyd, was one of Jack's best friends. Years ago, when Floyd got sick – he would die of congestive heart failure in 2002 – he asked Jack to look after Carol and their children.

Jack moved in to take care of Carol, but it is Carol who now takes care of Jack. It isn't an easy task.

"Nobody tells me what to do, where I can go," Jack says.

Carol laughs.

"Jack," she says, "is high maintenance."

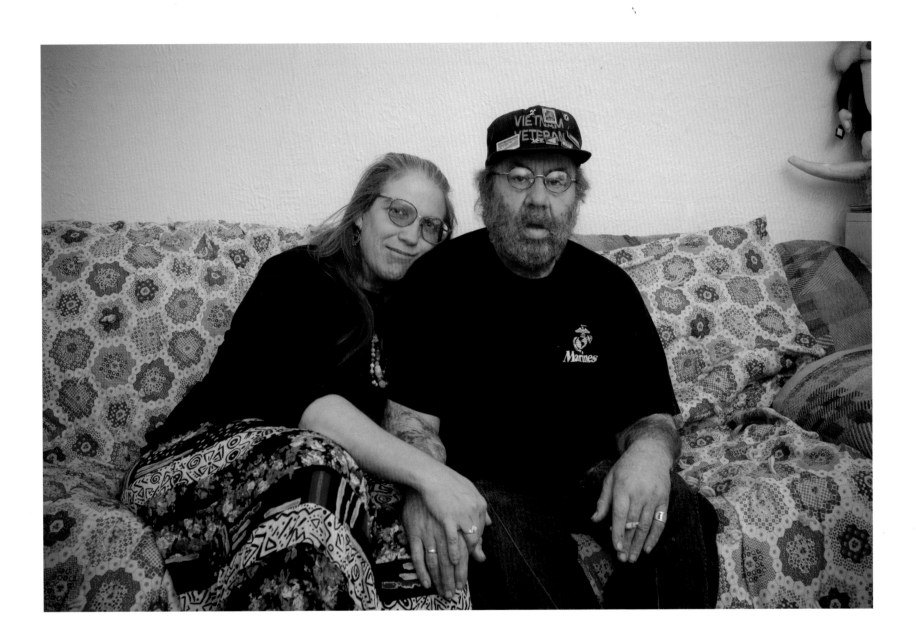

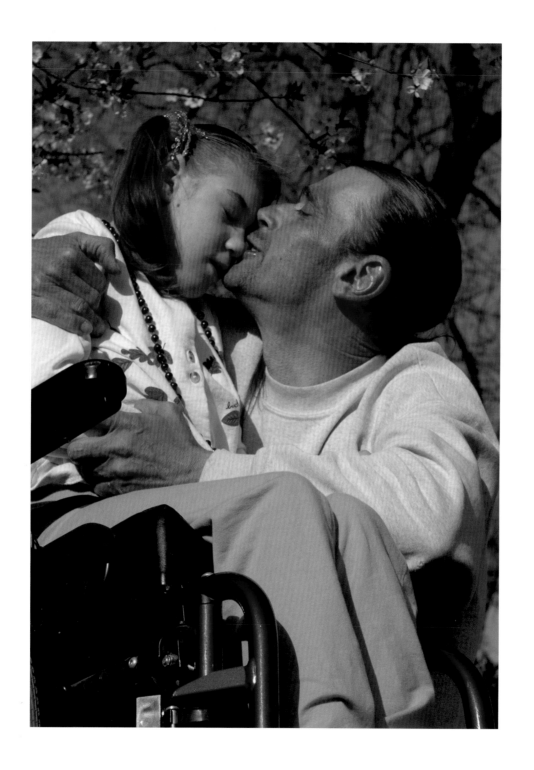

Chuck&Kelli

"In for the Long Haul"

Chuck Cutrano and his nine-year-old daughter, Kelli, live in a small house in the Town of Salem, Wisconsin. The rent is subsidized, but the house is too small. For the third time in two years, they're moving.

Kelli has cerebral palsy. The little two-bedroom house can't hold all the equipment she needs. Chuck hasn't found a new place yet. But already, most of their things are in boxes, and the boxes are stacked against the living room wall.

Not that they have much.

Here is the extent of their monthly household income: $603 in Supplemental Security Income, $223 in additional aid. That's it.

Chuck has looked for work. He says he can't afford to take a job. He says he's done the math over and over, and it doesn't add up. If Chuck were to get a job, Kelli's benefits would be cut, and what he might be able to earn above the cuts would be devoured by hiring someone to care for Kelli.

"I've asked job counselors: 'How do I stop this? How do I get off this? How do I go back to work?'"

"It's like I'm stuck. There is no future. I look at the long picture – I either give Kelli up, or I just keep doing what I'm doing."

"I love Kelli. She's my daughter. Give her up?"

"I've been overwhelmed. There have been times I've thought about it."

Chuck is seated at his kitchen table. The table is small. It has two chairs: a metal folding chair and loose-jointed wooden chair. Kelli is sitting in her wheelchair. Chuck leans over the side of the chair and kisses her.

"I'm in for the long haul," he says. "I'm not about to quit."

"But there are times I think about it."

Corie & Roger
"A Learning Experience"

Roger and Corie Frye, a father-son duo, are not at a loss for words. As Roger, the father, breakfasts on a savory feast of eggs and toast which Corie has prepared and placed on Roger's wheelchair tray, the words come fast and furious. The men are not happy.

"I hate it like hell," Roger says, of his condition, which carries the official diagnosis of "incomplete quadriplegia." He has only partial movement in his limbs after a head-on automobile collision 14 years ago.

"It's piss-poor being in this condition if you don't have a family member. Aides don't care if you're not a family member to them. They come help you when they want. Without family members, your existence could be next to nothing."

"They don't pay aides enough, and they don't give them health insurance, so they get people with low morale. And the result is, I could sit in my own feces for hours. I went through that. But a family member like Corie makes all the difference."

"I guess, on a positive note, I'm better off than a lot of people because of him. And it's a lot better to be home than at a nursing home."

Corie, a soft-spoken 26 year old, concurs with his father's discontent.

"It's mentally draining," he says. "When Dad goes to the hospital, the aides there don't assist him at all. He can sit in his own feces for three to four hours until I come and clean him. I clean him, and turn him so he doesn't get bedsores, but the hospital doesn't pay me at all."

For the past eight years, Corie has been taking care of his father for about 30 hours every week. Before that, he worked with him unofficially. The two have a smooth working relationship.

"It's a learning experience," Corie says. "And I look at life differently now because of this. Like, when I was young, in school, I might make fun of people in his condition. Now, I'm considerate of them."

Corie has sacrificed a good income he would have made as a self-employed contractor in order to take care of his father. "It's hard to describe," he says, "but man, I got closer to him. That's my best friend," he gestures to Roger. "We got tighter ever since the accident."

"Well, they need to pay the aides more money," Roger says again.

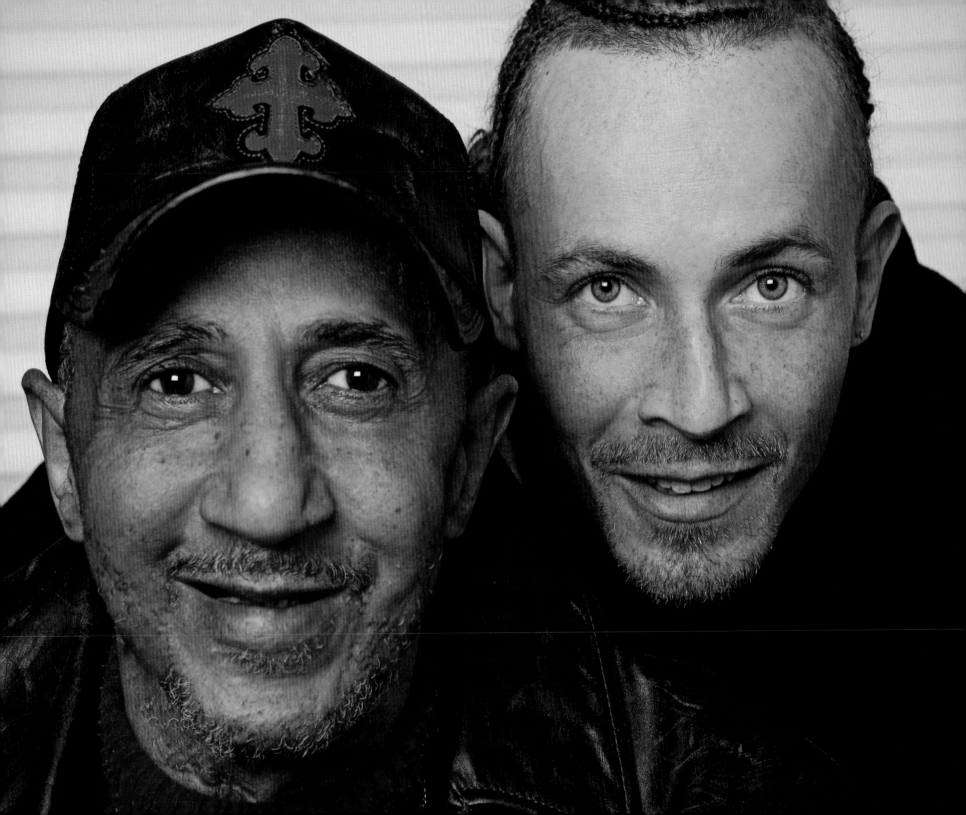

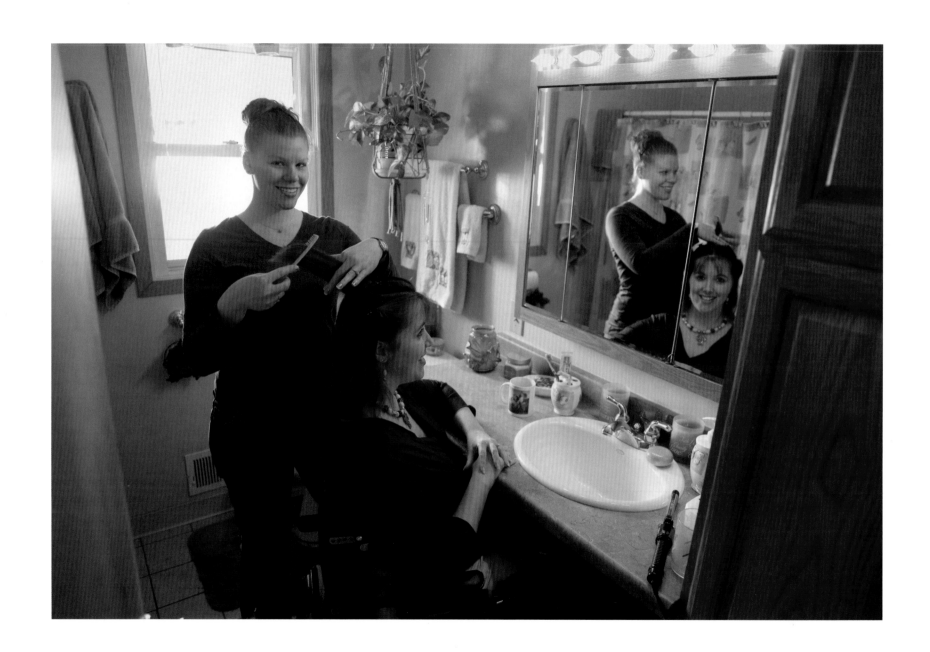

Crystal & Becky

"What Happens in the Bathroom Stays in the Bathroom"

If she could imagine it as a headline, Becky Trochinski's first week at college might read:

10 STRANGERS SEE WOMAN NAKED
Freshman also goes to a few classes

Before she went to college, Becky's only caregiver had been her mother. Now she was miles from home, dependent on people she'd never met to help her use the bathroom and undress for bed. And it wasn't always the same helper. She guesses that at least ten different strangers saw her naked that week.

Actually, the experience proved liberating for Becky, who had been shy and withdrawn. She shed her inhibitions and learned to speak up for herself – invaluable in dealing with the more than 50 caregivers she has had since she left home.

"A very small handful of people have come into my life who really are your caregiver," she says. She's an art teacher, with a highly expressive face and manner. Every phrase is punctuated by a raised brow or shake of the head. "Others are just working for the company."

Crystal Kuzera came into Becky's life when Becky's caregivers for nine years were moving on. "Crystal swooped in like a beautiful angel," she says.

"Oh, come on," Crystal scoffs.

"I'm not joking about that," Becky insists.

Becky's fiancé, Mike, nods his head. He's a hefty former Marine, with a ready smile. He took to Crystal right away, because she was the first caregiver who didn't treat him as if he were her unofficial backup assistant.

"Looking at it from my point of view, Crystal really is an angel," he says.

Crystal is 23, with a trim, athletic body and several discreet body piercings, which catch the light as she shifts and gestures. Her tongue stud blinks in the afternoon sunlight as she talks about her relationship with Becky.

"She has a very attractive personality," says Crystal. "She has a great sense of humor. She is a very straight-forward person. Becky says what's on her mind."

Becky prides herself on her determination to do things not typically expected of people with disabilities, such as having a baby. Even so, as a person with juvenile spinal muscular atrophy, Becky does need assistance with basic functions.

And, angel or no, the bond Crystal formed with Becky was forged in a decidedly earthy moment.

Crystal calls it "bathroom time." While helping Becky with her most basic needs, Crystal started to open up to Becky as a friend. She would ask her about her diagnosis, what it was like to be pregnant, how it feels to use a wheelchair.

Becky responded with her usual wit, but won't spill and tell.

"We have a rule. What happens in the bathroom stays in the bathroom," she says.

Roland & Mike
Bridging the Distance

The heart of Roland Escamilla's home is family. It has been so all of his life. The spine of his home. The flesh. The soul. All family.

Roland is married to Lynnda. They have a daughter, Nicole, and Roland is devoted to both. There is also Mike Gries. Roland is devoted to Mike.

Mike, who is 44, has cerebral palsy, spina bifida and a seizure disorder. He has also been diagnosed with bi-polar disorder.

Mike decided to live independently 11 years ago. He went through several caregivers during the first two years. Then came Roland.

Mike was dirty and his house was a mess when Roland came into his life. Roland went to work, straightening the house, getting Mike cleaned up. He quickly became Mike's sole caregiver, working ten hours a day, seven days a week.

It troubled Roland that the caregivers that preceded him had done such a poor job of caring for Mike. But what saddened him was that Mike's family hadn't intervened. How, he wondered, could they not have noticed?

Mike's father visited once a week. Usually it was to drop off groceries. Three years passed before Roland even met Mike's mother.

Mike's family was neither unkind nor unloving. Just distant. A birthday or a holiday would come, and Mike might get a card, but sometimes there wasn't a phone call, let alone a visit. Mike noticed.

"I could tell it hurt him," Roland says. "And that hurt me."

Caregivers often find themselves in the role of advocate, speaking on their client's behalf. And so Roland spoke to Mike's family.

One of Mike's sisters, a registered nurse, has moved back to town and takes an active role in Mike's care. Mike's mother and father call more, visit more, stay longer, and are more a part of Mike's life.

And Roland, whose sense of family is so vast, continues to ask, on Mike's behalf, for more.

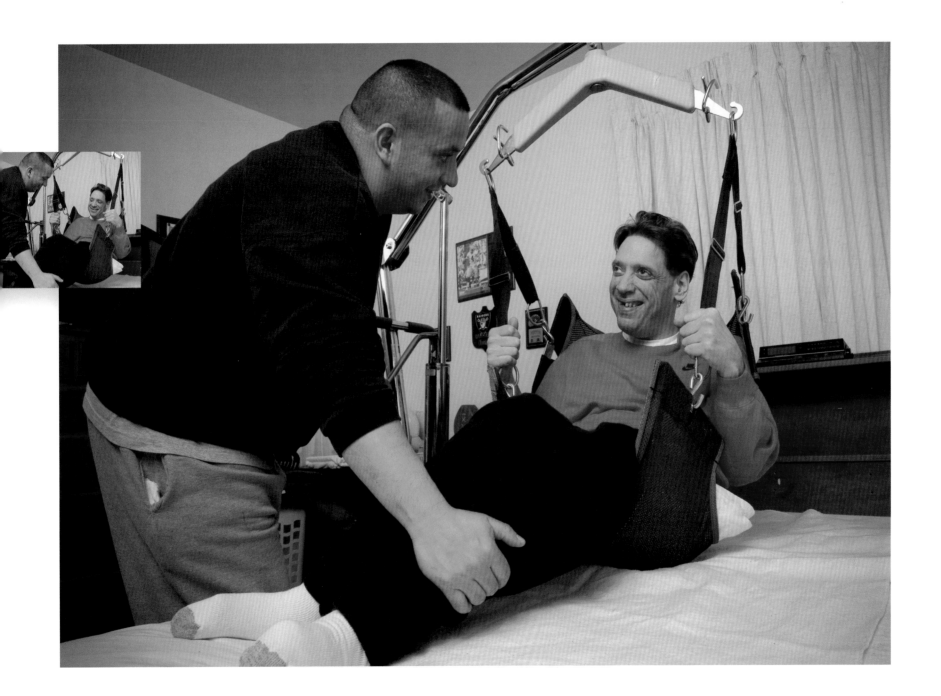

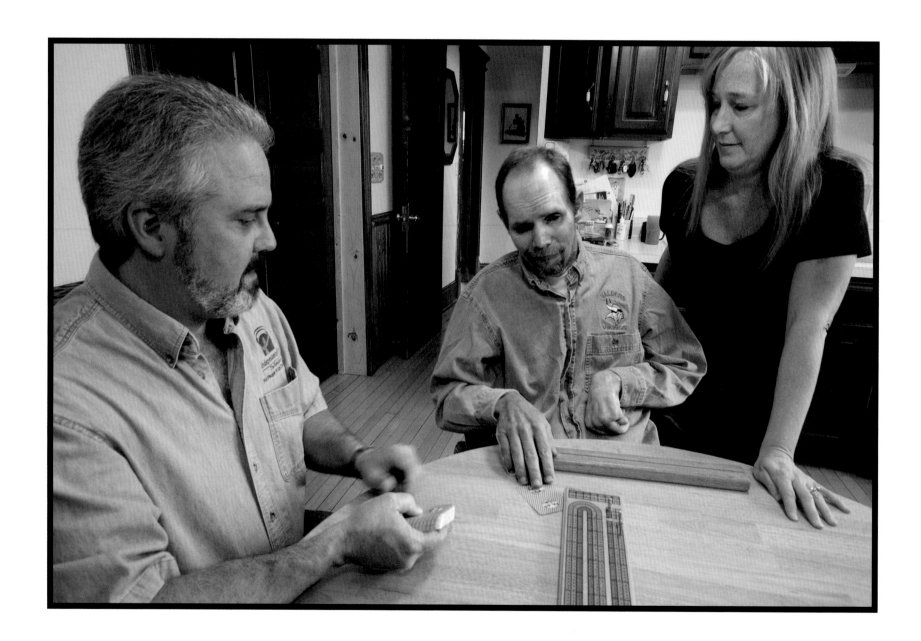

David, Ginger & Greg
"A Packaged Deal"

On September 24, 1987, at 2:20 a.m., Ginger Kenneke woke up and looked out her window. She saw an ambulance, lights flashing, heading up the road.

Ginger lived in a farming community with Greg Lueloff. They had a business together. They were to be married. The ambulance Ginger saw from her window was on its way to Greg, who had crashed his motorcycle just two miles from their home.

Greg suffered severe head trauma. Doctors expected Greg to die when they removed him from life support. He didn't. But he would need 24-hour care the rest of his life. Doctors told Ginger she should institutionalize him. She didn't.

Ginger moved with Greg to Milwaukee. She cared for Greg and worked in a bar to make ends meet. A couple of years after Greg's accident, Ginger met David Reimer.

David was in college, studying tool and die making, and working second shift at a manufacturing plant. He asked Ginger out. On their first date, she told him, "I take care of Greg. Wherever I go, he goes. We're a packaged deal."

Ginger thought any man presented with that situation would walk away. David didn't.

In 1990, David quit his job as a tool and die apprentice, earned his nursing assistant certification and became Greg's home care provider. On November 4, 1995, David and Ginger married.

It took David years to earn Greg's trust. Greg struggled against him. He was afraid that David and Ginger would abandon him.

They didn't.

Today, David, Ginger and Greg live, along with two dogs, in a house they have modified to accommodate Greg's needs. Ginger works for a disability rights agency, managing its personal care program, and David continues to be Greg's primary caregiver.

Who could imagine three individuals making such a journey? But they did. Together.

Alla & Jennifer
Overcoming Barriers

Jennifer Goetz is howling with laughter in amused recognition of the truth her caregiver, Alla Manson, is speaking.

"Jennifer is a little bit Scrooge," Alla has said, in her thick Ukrainian accent. "Not too bad. But, when it comes time for me to cut, say, a portion of cake, she will tell me to cut in quarters. Then she will watch me like a hawk as I'm cutting, to make sure I'm doing it exactly accurate, to the tiniest part."

Jennifer is laughing so hard it's almost disconcerting. She might break her ribs!

A conversation with the two has a definite pattern. Alla is loquacious and rambling, covering much territory, while Jennifer listens and laughs.

The relationship wasn't always so much fun. Three years ago, when Alla, who came to America from Ukraine in 1996, met Jennifer, the language barrier seemed insurmountable to both women. Jennifer experienced a stroke in her brain stem in 1970, and it is a challenge to understand her when she speaks. At the time of their meeting, Alla's accent and English vocabulary also made her difficult to understand. Their mutual challenge discouraged them both.

"All my life I've been taking care of people," Alla says. "But with Jennifer, after meeting, I'm thinking, only one time do I stay with her. I'm crying. The language problem was so bad, and I had training in different programs, with different care requirements. I find new client."

Alla has an earnest, vivid personality, and it's hard to imagine her quitting easily at anything. So the two continued with the care arrangement: Alla stays with Jennifer for two 24-hour shifts during the week. Jennifer receives additional help from other caregivers.

"We were uncomfortable for six months," Jennifer says. "I didn't really say, 'I don't understand you,' but we both knew it. But the barrier eventually faded. If you persist in some tough relationships, oftentimes you'll find a real pearl, like I did. She shares everything. I am a happy person. I have my needs met."

Alla, smiling broadly, takes back the floor.

"I have a philosophy given me by my mother. She said, 'When you put something in your pocket, and save for yourself, you lose it. But when you share what you have, you keep it.' Maybe this philosophy is not normal, but for me it is."

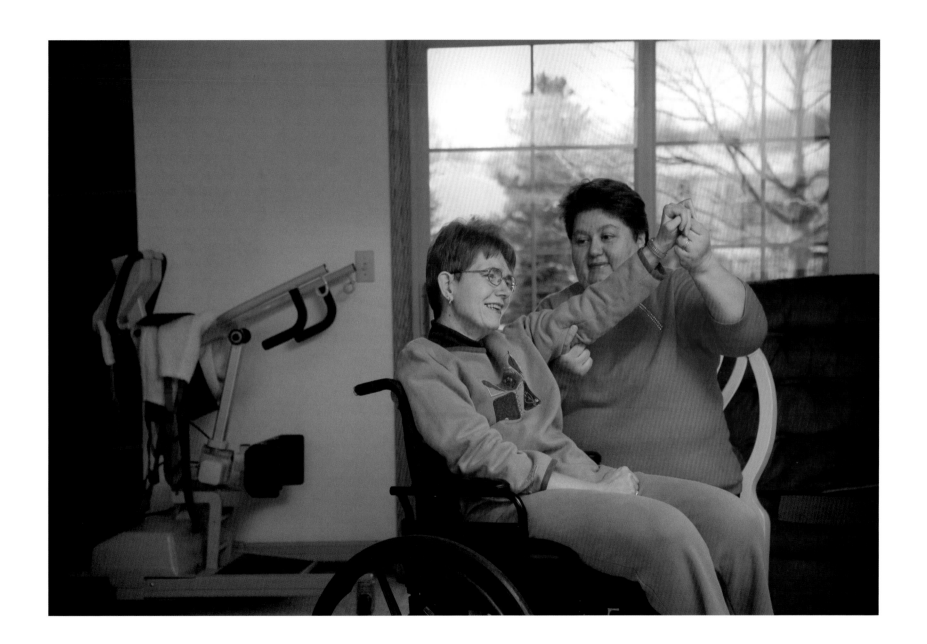

Deb & Jim

Sustained by Mutual Effort

Jim Olsen and his wife were building a home, parenting two kids and expecting a third when, in the fall of 1980, he was diagnosed with multiple sclerosis.

MS wasn't the only reason, but it was part of the reason that Jim moved out of that home 20 years later. He believed his illness was a burden to his family. His presence, he believed, misshaped their lives.

The years that followed were a journey toward independence. Jim moved to a nursing home, where he remained for about a year and a half, then to an assisted living facility, where he remained for a few months, and finally to his own apartment.

Jim's independence depended on reliable home health care, and he had an uncomfortable relationship to the irony of this situation. He fantasized about being MS-free, about being utterly independent.

Although his health care worker was critical to his life, Jim found himself, in testing the boundaries of his independence, in quiet rebellion with his caregiver.

"I am constantly striving to be more independent," Jim says.

"Sometimes, I revolt. I am wrestling with the fact that I am disabled, that I have a liability."

Deb Johnson has been Jim's caregiver for more than four years. He admires her deeply, and in part what he admires about her – besides her competency, her kindness, her humor – is her strength.

She is strong enough to handle him.

"He's like a teenager sometimes," Deb says.

"We argue," Jim says.

"Oh yes, we argue," Deb says.

And so, together, they have learned that the relationship between caregivers and the people who receive their care is a complicated one indeed. Deb is not Jim's slave. Jim is not Deb's child.

Deb has a life independent of Jim. Jim has a life independent of Deb. The intersection of their two lives is not unlike the intersection of any two lives. It is a relationship and, like all human relationships, it is sustained by their mutual effort.

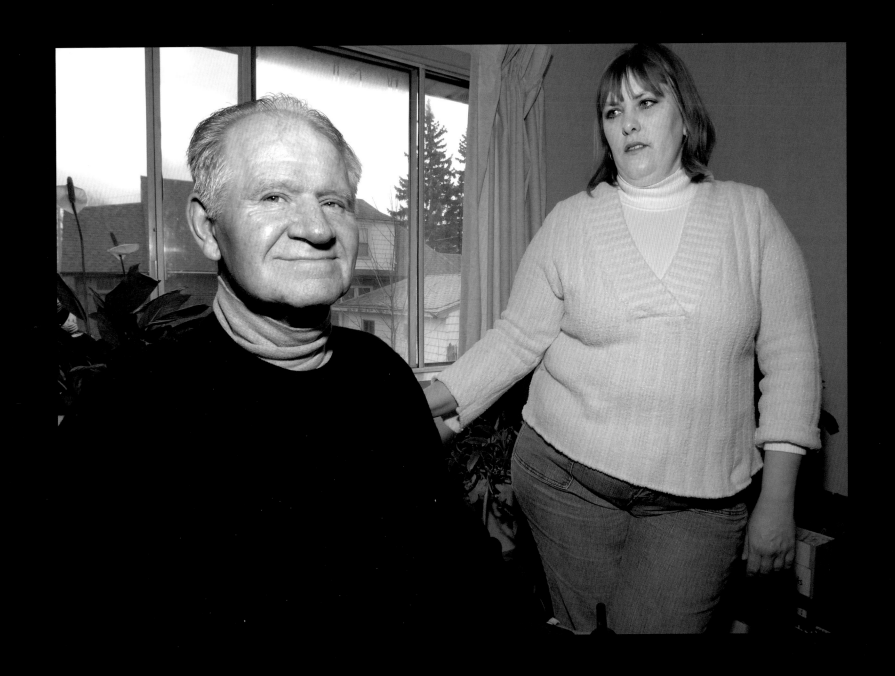

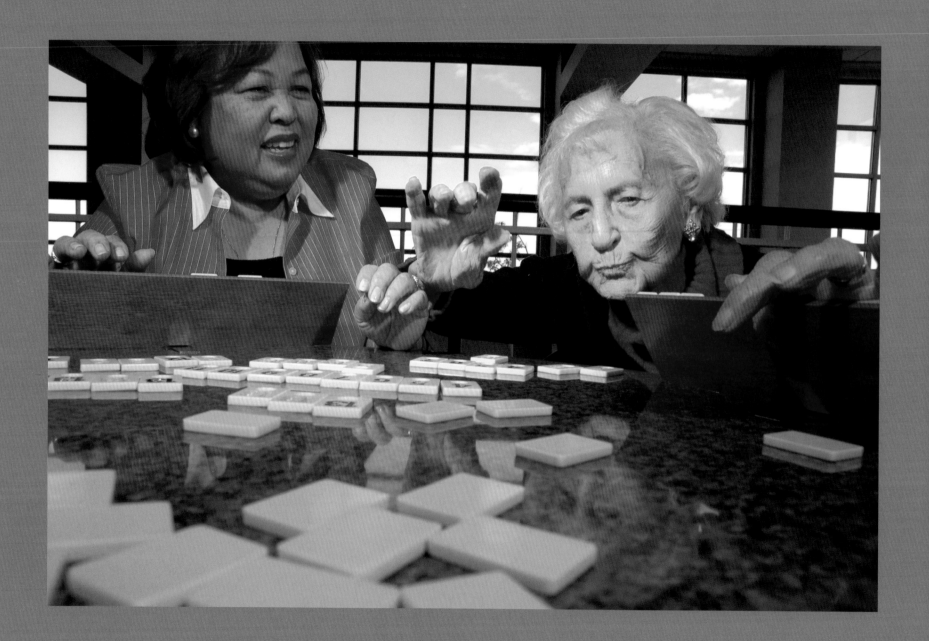

Erlinda & Meta

Inconspicuous, Yet Reassuringly Present

Meta Baruch is 97 years old.

Born into a Jewish family in Germany, Meta was a young woman when the Nazis came to power. A widow for nearly four decades, she has learned how to make her way through this world.

Erlinda Dial is 61. She was born in the Philippines, one of ten children. She was in her mid-50s when she, her husband and youngest son immigrated to the United States, settling near Chicago.

Meta lives in an elegant independent and assisted living community overlooking Lake Michigan. She was one of its first residents and calls herself a pioneer.

A year ago, Meta was told that she required an around-the-clock caregiver, someone who would look out for her 24 hours a day, seven days a week. Meta was less than keen on the idea. She considered herself a strong and independent woman.

And so she politely bristled when Erlinda came to stay.

"I felt it," Erlinda says. "She had been very independent for 96½ years."

It bothered Meta to have Erlinda around all the time – helping her do this, helping her do that. Meta told Erlinda she could do it herself.

Erlinda would tell Meta, "It's okay if you don't need me to help you with this. We just want you to be safe."

What Erlinda is trying to do for Meta isn't easy. She is trying to take care of Meta in a manner that not only preserves Meta's independence, but also, without compromising her care, preserves Meta's sense of independence.

"I try to be inconspicuous," Erlinda says.

Inconspicuous while, at the same time, reassuringly present and firm.

Erlinda says, "Whatever is for her good, I insist."

Eulanda & Betsy

"Do Not Let Your Hearts Be Troubled"

Eulanda Booker is excitedly holding a copy of the Bible out for a visitor to read as she recites it from memory.

"Do not let your hearts be troubled," she says, as Betsy Jackson, her friend and care recipient, listens attentively. "Trust in God still, and trust in me. There are many rooms in my Father's house; if there were not, I would have told you."

Eulanda beams, and bursts into energetic laughter.

"You see," she says, "we both believe in God. We have that in common. Also, we don't drive, either one of us. And we have our hair the same way."

Sure enough, they have the same hair styles. Eulanda, a sprightly woman of 31, has been bursting into loud laughter for the past half hour. "Miss Jackson," as Eulanda calls Betsy, will soon turn 80. She has been talking about her offspring.

"I have nine children. Eight of them are alive, but they killed one."

"They didn't kill your daughter," Eulanda says with a smile. "She died of cancer."

"Yes, she died of cancer," Betsy says. "But they killed my brother John in Detroit, when they hit him on the head."

"I have five daughters and four sons. I come from Mississippi, and so do Eulanda's folks, so, you know, we might be related somewhere down the line. And Eulanda has three children of her own, so we're related by both being mothers."

Eulanda erupts into laughter again.

These two have been together for two years – first, when Eulanda was a substitute caregiver, and then, for 20 hours per week in the last eighteen months. Eulanda bathes Betsy, and helps with chores in Betsy's neat, snug home, but it appears that the primary service Eulanda offers is companionship.

"I help her through her bad days," Eulanda says. "She reminds me of my grandmother, because she's so strong. But some days I have to talk her into getting things done, and she just needs a little understanding. I help her get going."

"Life is what you make of it," Betsy chimes in. "We're all human."

Eulanda pauses to consider Betsy's statement.

"I love older adults," she says. "This work is something I've always wanted to do."

"You've also got to put in your book that we have in common the television show 'Passions,'" Betsy says. "Put that in your book and we'll sit back and read it, and laugh."

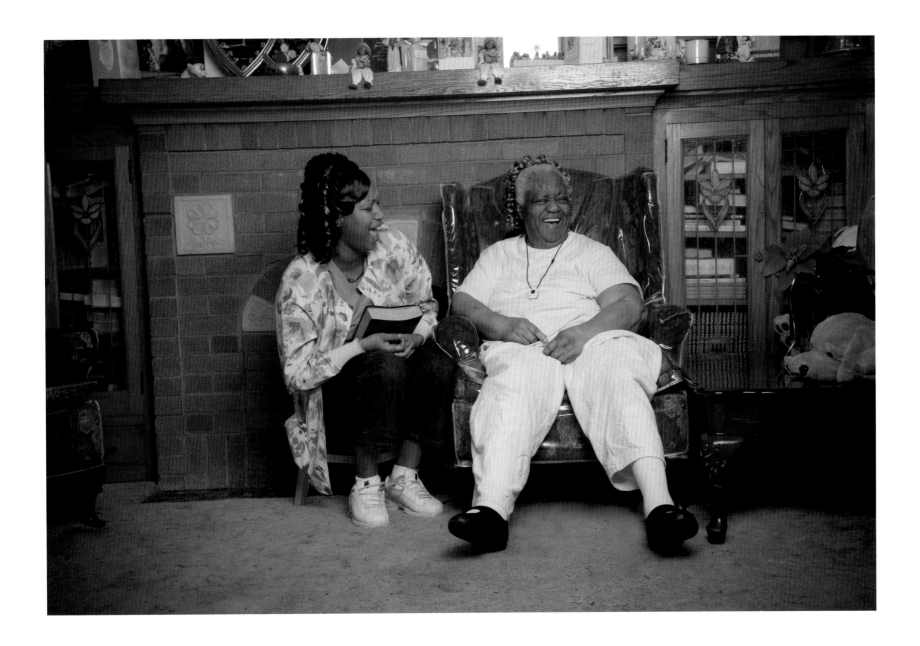

Jacqueline & Frank
Respect

Frank James has overcome seemingly insurmountable odds. He's learned to cope with the loss of use of his legs and hands, and kicked a drug addiction. That survivor's strength should serve him well as he faces another challenge: loss of his cherished caregiver, Jacqueline Robinson, who is moving out of state.

Seated in his wheelchair, soft-spoken Frank reports that his disability, "C5-6 quadriplegia" – referring to his broken fifth and sixth vertebrae – came about during a fight in 1988. The trauma led to years of depression, fueled by drug abuse, until he reached rock bottom, and phoned his estranged mother, asking for help, beginning an ascent towards dignity.

Jacqueline Robinson had gone through 25 clients in five years, finding it hard to locate a match she could work with comfortably and respectfully. A self-effacing Mississippi native, she has been providing Frank "cares" such as showering and dressing, and "bowel and bladder" for five years, and the two have grown close.

It is a friendship of kindred, humble, but strong spirits. The affection between them is palpable.

Frank says of Jacqueline, "I love her to death. We have a real close relationship. She's my therapist." He discovered that he has the power to cope with life's challenges, and having Jacqueline at his side has been a tremendous boost.

Jacqueline says of Frank, "He always treated me with respect. His main word is 'Thank you.' That's a big plus, and that's what kept me coming back."

Their relationship has become so trustful that she goes beyond the call of duty for him, "going to the cleaners and the bank," and handling "money to trust," as if the two were family.

When Jacqueline decided to move south, her primary concern was that it was going to be "hard for me to tell Frank." When she mustered the courage to do so, he said, "I'm going to miss you," but called upon his inner strength to cope. Jacqueline and Frank will continue thriving. They are both too powerful, in their quiet, grounded ways, not to.

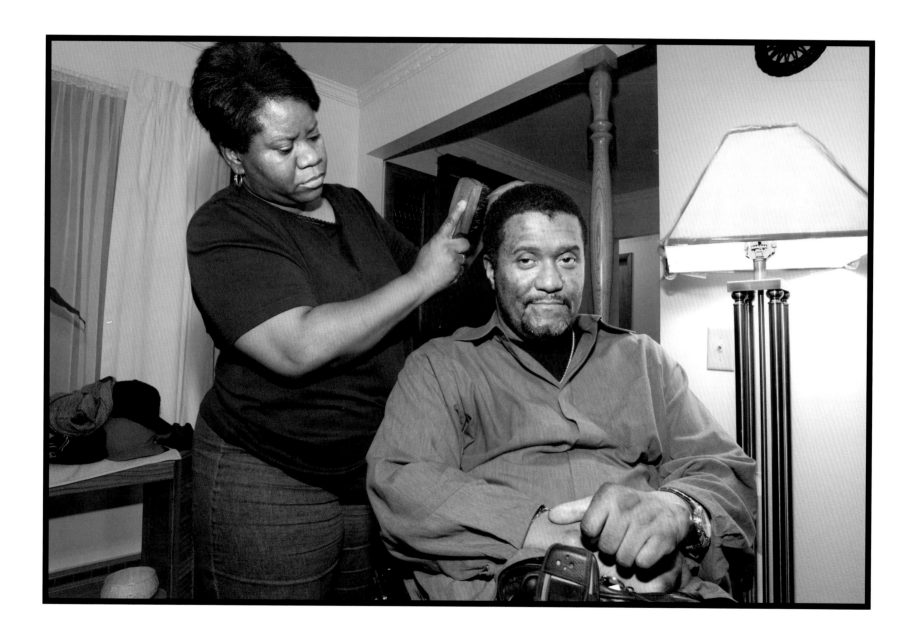

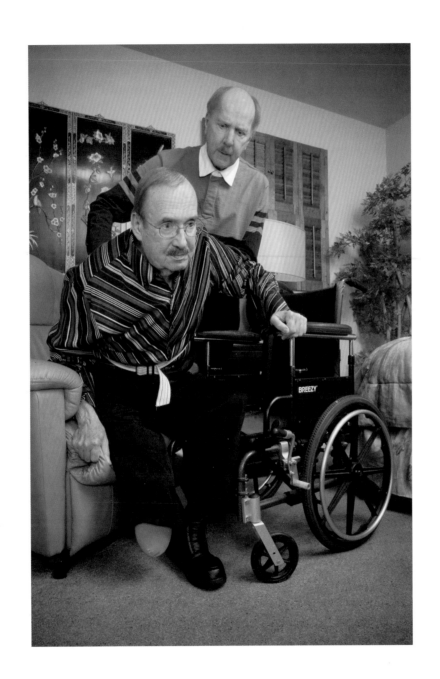

Jim & Phil

Overcoming Challenges with Humor

The home shared by Jim Drost and Phil Vitrano is unprepossessing from the outside, but stunningly beautiful indoors, featuring gorgeous Asian motifs. The two are also unprepossessing physically, but their insides are deeply impressive. They are kind, gentle, and charming. They've been best friends for 52 years, have been through a lot together, and, when Phil's diabetes became more and more inconvenient, Jim, without hesitation, moved in with him to help.

"I don't think of this so much as an act of 'caregiving,' as it's simply an act of friendship," Jim says quietly in his dining room, looking fondly at Phil.

Phil has had diabetes for 22 years, and had to have his toes removed a few years ago, then lost his foot and leg up to his knee in September of 2005. He's learning to walk with a prosthesis, which is hard for him, and the two are learning the trials of moving a wheelchair around in the world.

"The irony of this is, my pancreas seems to have started working again," Phil says. "My blood sugar level is down, I'm off of insulin, and I've been discharged by my doctors. That's good news for me, after I've already gone through open heart surgery, cancer surgery, 13 eye surgeries, and artery surgery on both my legs."

Jim describes the relationship he has with Phil. "We grew up together. We're like brothers. We're considerate of each other. As far as each other is concerned, we're selfless."

Phil nods in agreement.

"And we laugh a lot together," Jim continues. "Say, if we're out in a restaurant, and my pal has to go to the toilet, we don't know what the toilet is going to be like. Handicapped-accessible toilets are still very difficult. And sometimes you go to a restaurant advertising itself as handicapped-accessible, and that just means the bartender will come out and help me lift Phil and his chair over the stoop. We take all this with humor. We enjoy every day as much as we can."

"We very much have a good time," Phil contributes.

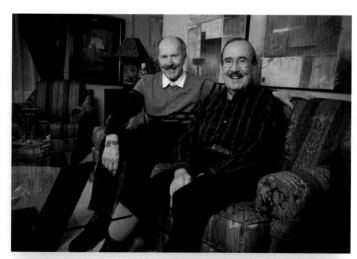

"The first couple days Phil was home in his wheelchair," says Jim, "we had to figure everything out. It's amazing the challenges you don't think of until they confront you. But, we think positively all the time. That's the most important thing. We don't bring negatives into our home."

Josie & James
"My Home is Right Here"

The day Josie Armour came to James Lee, he didn't want to get out of bed.

He told her on that June day six years ago he was ready to give up – but he wouldn't get up.

"James, you got an old pusher here. You gettin' up."

"No, I ain't."

"Yes you are."

When she saw where James lived, Josie almost turned around and walked right back out, "that's how bad it was in here." He had a kitchen table and a bed. That was pretty much it.

"The Lord just told me to go in here," she says.

Josie has a daughter, four grandchildren and a fiancé, but "my home is right here with James."

"And I thank God I'm here."

"Me too," James says quietly.

Before Josie came, James's days were a string of afternoons spent sitting at his kitchen table, drinking booze, smoking dope, until the tiredness would hit him and drive him to bed. He was sad about his mother's passing. She had struggled to keep him at home as his age and cerebral palsy required more attention.

Josie didn't judge him, but she told him she wouldn't buy liquor or cigars when she did his shopping. He'd have to get those for himself.

James had already quit the booze – "I knew it was going to kill me" – and with Josie taking care of him, he was soon done with the dope, too. She went to garage sales on her days off, picking up a chair here, a bookcase there, to brighten the place.

She shaved him, washed his clothes, listened to him complain and told him her problems. She brought her grandchildren to visit. One Easter, James bought candy for them.

James wasn't mean, as some said, just "sheltered," Josie calls it. He couldn't be bothered with people.

Now, he takes trips to the stores by himself and chats with people on the way, smokes the cigars he couldn't give up, even for Josie, and donates to "Toys for Tots." He might be gone four hours. He gets home to find Josie has roused the neighbors to look for him.

"That's when I know you really love me," he says. He buys her presents, which he hides in her handbag to find when she gets home.

Sometimes James, who was born and bred in the Midwest, will be finishing a sentence for Josie when he'll slip into her gentle Tennessee drawl. People ask him, "Is that your wife?"

"And I say, 'No,' she just yells at me like she's my wife."

Josie laughs.

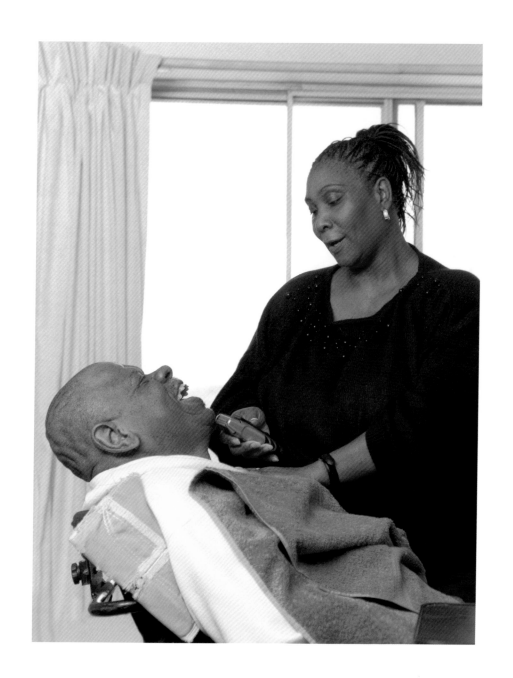

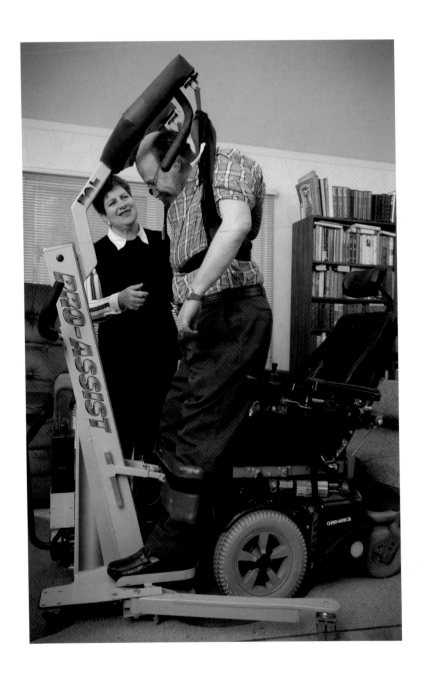
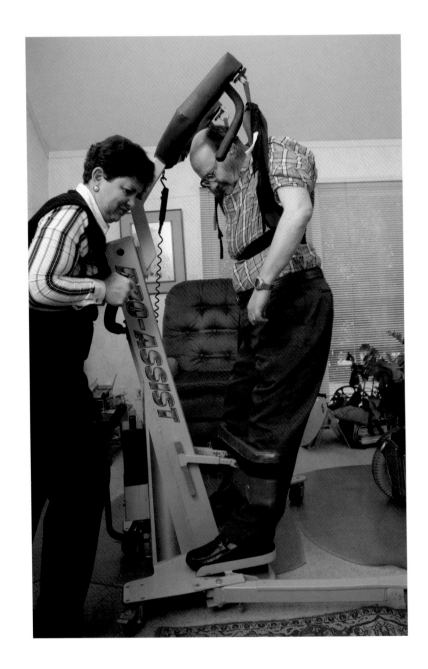

Joyce & Frank
"*Putting One Foot in Front of the Other*"

Neither of them hears the delicate, rounded trills of their South African accents. They have been here, after all, since 1981, which is surely enough time to swallow the sounds of the past.

"We think we sound like Americans," Joyce Rubensohn says. She pronounces it "Ameri-cawhns," a charming reminder that what we were is always a part of what we are.

Frank Rubensohn's multiple sclerosis hit relatively late. He was 46. He and Joyce had already raised their two boys. Frank didn't know what to think.

"I think I was more realistic than Frank was," Joyce says. She was resolved. "You have to be pretty strong in your wishes of caregiving."

The Rubensohns are experts at adapting.

They left behind their warm country, everything they knew, to come to the other side of the world when Frank was offered a job at a mannequin maker. Frank used to design mannequins.

There they were in Wisconsin six months later, in winter – and the mannequin company went belly up.

What would Frank do? Mannequin manufacturers aren't exactly on every corner.

Then a friend asked them to manage his instant photo processing shop – a new concept in those days. They adapted again.

When Frank became ill, Joyce, the realist, had to tell Frank, the optimist, what he couldn't do. No driving. No walking.

They fought over whether to sell their house, with the bedroom upstairs. Joyce's heart stopped every time she saw him teeter on the steps. He wouldn't sell the car, though Joyce struggled more to get him in it as he got weaker.

Frank chuckles at his folly, but he can explain it: "Every time you lose something, you feel another part of you going."

Joyce works full–time at a medical clinic and they have aides who watch Frank during the day. She handles the toughest part of the caregiving. She feeds and bathes him, helps him to bed. She relies on equipment such as a mechanized lift that helps Frank to stand; it enables him to stay at home with her.

There are some parts of the past they strive to preserve, such as their weekly dinner parties with friends.

"Joyce has been fantastic." Frank marvels at his wife's ability to manage time, to remain calm, to adapt.

"It is really a matter of putting one foot in front of the other," Joyce says. "You just do it."

Frank's soothing nature, his optimism despite everything, impresses her far more.

"We have friends who call to seek his advice – his therapy," she says. When they are down, "They hope to get some solace from him."

If he can take what he has taken and still find a way to console others, she tells herself, she can certainly get through today.

Katherine & Her Family

The Caregiver Contract

THE CAREGIVER CONTRACT

The Pact: If you but allow her breath, Lord, I will use all my power to comfort.

The Promise: When you call her home, Lord, I will let her go joyfully.

The Price: My vision, so distorted, I see only beauty through tears of sorrow.

My strength, so weakened, I claim only the power of God. My heart, so broken, it can contain only love.

The Caregiver Contract at left was written by Katherine Krahling. It was inspired by a lifetime of caring for people with mental, emotional and physical disabilities.

Katherine, who is 58, is the biological mother of three children and the stepmother of one. Her oldest son, Alexander, who is 40, has learning disabilities and a heart condition.

Katherine is also the adoptive mother of six children, all of whom have disabilities.

"When your first child is born with disabilities," Katherine said, "you learn two things. One, you learn not to be afraid of people with disabilities. And two, you learn they are God's greatest gifts to us as people."

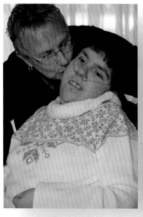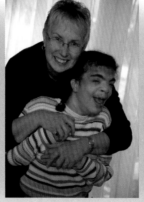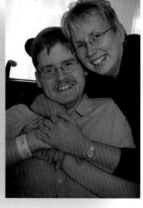

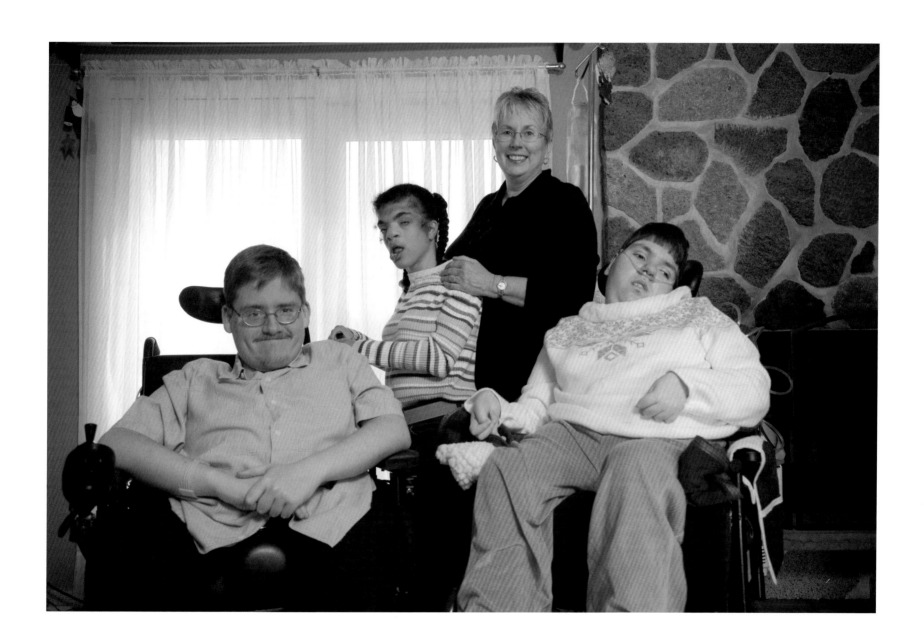

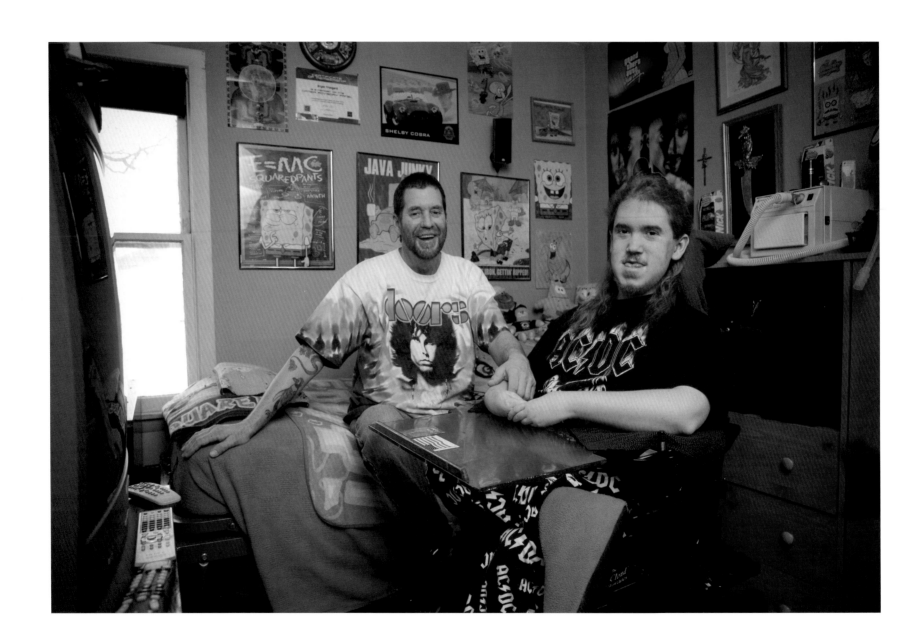

Kevin & Bryan
A Rock & Roll Bond

Kevin Trongard sits smiling beside his son Bryan, massaging Bryan's arm methodically. Kevin's been speaking with enthusiasm about the rock concert he took Bryan to months ago, and Bryan's been nodding his head along with each word.

Kevin is wearing a Doors t-shirt, and Bryan is wearing a t-shirt and pajama bottoms emblazoned with the logo of the band AC/DC. They have a rock and roll bond.

"See, AC/DC is Bryan's favorite band," Kevin says. "And penguins are his favorite animals. So, look." He points to a tattoo on his forearm, of a penguin wearing an AC/DC jersey. The name of his son is also tattooed on the arm.

"I worked installing insulation for 23 years," Kevin begins, explaining how he came to be his son's primary caregiver. "But Bryan, who was born with muscular dystrophy, was getting bigger and bigger by the time he was 19. He got harder and harder for people to move in case of emergency. He'd stand 6'1" if he could stand. So, two years ago, I just thought, what if something happens and I'm not there? So, I got a job taking care of him. I like it a lot."

He's still kneading the skin on Bryan's forearm with quiet solicitude.

Kevin responds to a question regarding the frustration of caregiving by becoming quiet and thoughtful.

"A frustration is when you get to a place that's not handicapped accessible even though it claims to be," he says, and Bryan nods his head vigorously. "Another frustration is rude people not getting out of the way. Sometimes, people see him coming, and he has a little horn on his wheelchair which he toots, and then he bumps into their toes, and they get mad at me. 'What's wrong with your son?' That's totally frustrating."

"I also get frustrated," Kevin continues, "when people get an attitude and stare. And you know it's funny, people say it's the kids who will be rudest, but that's not our experience. Kids are nice. It's the adults who bother us."

Bryan is asked about the frustrations and satisfactions of his experience. He jumps on the latter.

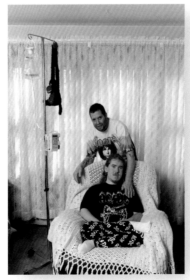

"I love doing something people say I can't do. Straight A's in high school, surviving to age 21, coming home from spinal fusion surgery earlier than expected, with nothing but aspirin for a painkiller."

"And, the best satisfaction of all is being with my Dad. He's a lovable guy. He means everything to me."

Debra & Donna
Seeing One Another Through

Debra Jones looks drained of energy as she studies a visitor through weary eyes. It's 5 p.m. and she reports, "I'm tired. I could go to sleep right now."

Across the room, Donna Dennie, whom Debra works for seven days a week, is talkative.

"I'm always perky," Donna reports. "Debra gets here at 3:30 in the morning every day, sometimes 4, and even then, without coffee or tea or anything, I'm full of things to say. And Debra has to say 'Can we just not talk?'"

Not only is Debra Donna's employee, she's also her younger sister by nine years. They've been working together for 13 years.

Donna has had muscular dystrophy for 27 years, since she was 13, and uses a wheelchair. In the early phase of the disease, her mother was told by doctors that she had only a year to live, and later, when she was in intensive care, they said Donna would die within 24 hours. Donna has survived, graduated at the top of her high school class, earned a college degree, and even, against all medical odds, given birth. These accomplishments are not hard to believe for anyone spending time in her vigorous presence.

"I never thought I would die," she says. "That was from Mom instilling in me about God. You've just got to go beyond believing in men and medicine. When we were at the worst, I told Mom, 'I'm not going anywhere. God visited me at the bottom of my bed. I have too much work to do for Him.' I went into remission."

Debra arrives at Donna's home in the dark each morning, and does a series of chores – ironing, bathing Donna, helping her with toilet, dressing and grooming her, preparing breakfast, gathering Donna's things, and, then, after the transit bus has left at six, tidying the household. Debra, who also has parenting responsibilities at home, returns at 5 each evening to, as Donna puts it, "start all over again, undoing everything."

"I've known her all her life," says Donna. "I used to take care of her when Mom worked and we were little. Now, it's like nature has taken us full circle."

Debra says, "It can become overwhelming."

Donna says, "Debra shows me every day that we are not primarily put on this earth to see through one another, but to see one another through."

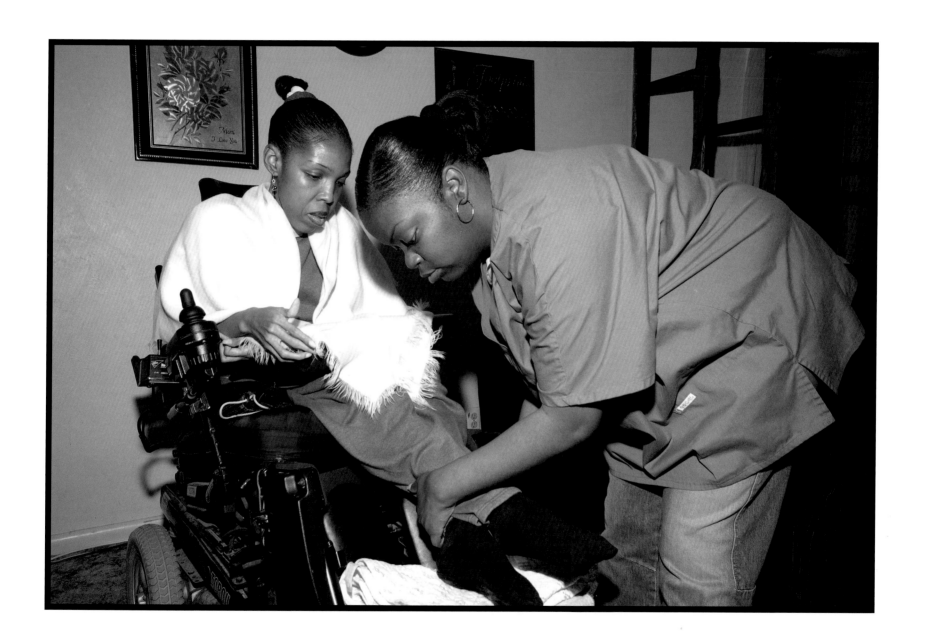

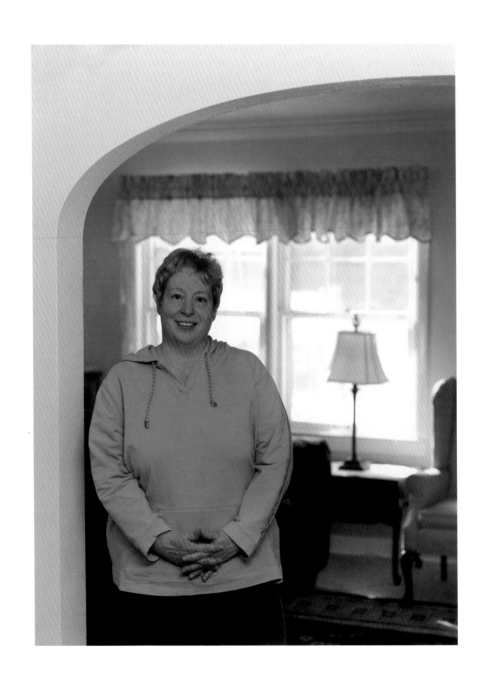

Jan & Jane

Tears and Joy

A glimmer of delight plays on Jan Lewandowski's face as she remembers her friend, the late Jane Knebes. Even though the hint of tears is present in her eyes, her joy is unfeigned.

"I answered an ad for a caregiver," Jan reports. "I wasn't sure if I could be good at that, but I thought I'd just meet her and see. When I did, I saw that she was desperate. She was a quadriplegic, and had no family whatsoever in the area."

"I liked her. Our friendship was immediate and strong until her death in 2005."

Jan cared for Jane for seven years.

"It was hard work. She was a perfectionist who wanted things done her way. She couldn't do anything for herself, from scratching herself to going way to the back of the store to check out a yellow sweater I knew she wouldn't like anyway. But, she helped me as much as I helped her – me being a single mother of teens."

The women went on numerous shopping outings, and to the movies and dinner. Their personalities "clicked," despite an apparent conflict between Jane's fastidiousness and Jan's easy-going ways. Jan has a sunny, amiable nature, and she reports that Jane had a positive attitude, and "didn't let her condition bring you down."

That condition was multiple sclerosis, which Jane lived with for 32 years. In her last year, Jane's ability to speak, breathe, and swallow, waned.

"One day I found her sobbing. She said, 'I can't do another day.' We had always known the time would come, and neither of us had a bad feeling about dying, because we all have to go. It's natural. We just knew she was ready."

Jane checked in to a hospice, and stopped eating and drinking altogether. She died five days later.

"We planned it around my vacation at work, so I could spend the final days with her. The day before she checked in, she said, 'Don't forget to take all that toilet paper I just bought.' She wanted her hair washed just eight hours before she died. She didn't want to die with dirty hair."

A day and a half before Jane died, as Jan sat beside her in the hospice, Jan felt a pat on the shoulder, and immediately thought, "That's Jane's deceased mother." She told Jane of this when she later awakened and Jane replied, "She came to thank you."

PHOTO: COURTESY OF THE FAMILY

Leni & Lena
A Rewarding Puzzle

Leni Villanueva loves to solve puzzles. She clips the Sudoku challenges from the newspaper to play on those long plane trips to California to visit her family.

Like all good puzzle-solvers, Leni is equal parts psychological detective, escape artist and creative opportunist. Every obstacle is a challenge; every opening a path to solution.

For Leni, caregiving is like an entire volume of Sunday Sudokus, the most irresistible and most rewarding puzzle there is.

She came to the work by chance, after her high-paying job with a jewelry maker dissolved. But Leni discovered that being someone's constant companion made use of all her special skills, some she didn't realize she possessed.

Leni knew, for instance, that she could cook. But even she was surprised at how she learned to wield that skill like a fine weapon in the gentle war to win over a reluctant client.

Take Lena Goldberg. Lena was 92 when her family hired Leni to care for her. Lena wasn't pleased.

"She is a very independent woman," Leni says. "She is very intelligent and very sensitive to people and what they think of her."

Lena ignored Leni for the first few days, hoping, perhaps, that she'd just go away. Leni rubbed her hands together. Here's a challenge, she thought.

Leni is a petite woman, with a sweet smile and deferential manner that belie a tenacious and perceptive interior.

"She was very fond of food," Leni says, explaining her strategy to crack the code that was Lena Goldberg. "Soon, I see this was a way through to her. I would entice her with the food."

Leni made Lena chicken soup "the Filipino way – with the bones," Chicken Adobo, a popular Philippine dish, even Spanish paella. Lena approached each one with gusto.

Leni, who has a degree in fine arts from her native Philippines, recognized the older woman's love of art and would pencil drawings for Lena to shade and color.

"It's not bribing," Leni says. "It's getting to the core of the person."

Soon Lena "came to love me," Leni says, as Leni loved Lena.

Lena recently moved to a facility with more intense care. Leni visits often.

Now Leni has a new "elderly lady," her fifth such client in eight years.

"Some people call being an aide a sophisticated term for a maid," Leni says. "I don't look on it that way."

"With this job," she says, "I've been able to realize my dreams."

And solve some of life's most intriguing puzzles.

PHOTO: COURTESY OF THE
GOLDBERG FAMILY

Linda, JaVeda & Kenneth

"Some Days It's Peaceful. Some Days..."

Linda Walker didn't hesitate. She didn't care what people thought.

She took them in because they needed help and love, and she was the one to do both.

JaVeda, now 12, was the daughter of Linda's husband by another woman. Kenneth, now 11, was JaVeda's brother. They were babies then. Both had tested HIV-positive.

"I said 'bring them to me,' because that's just the type of person I am," Linda says. "It was meant to be. I treat them no different from my other children."

Yet, because of their condition, they do require more care. Kenneth is on a regimen of medications and both children make frequent trips to the hospital or the doctor's office for tests, shots, more tests.

Linda juggles the intricate schedule "all in my head," while still caring for her other children and grandchildren.

Kenneth has behavior challenges at school; Linda has him on a daily report. This has helped to reduce the instances of "wilding out," as Linda calls them, but it has made her day more complicated.

On top of that, Linda takes her own medicines for high blood pressure, diabetes and other health problems.

"I should be crazy, I know," she says with a chuckle.

She does it all by making her will the law. Linda is no shrinking violet. She has a powerful voice and she's not afraid to use it. Everyone in the house must follow the law. No exceptions.

She's a benevolent dictator – she makes them laugh, too.

"JaVeda is on a see-food diet," Linda says, with a veteran comic's deadpan delivery. "We want to see how much food she can eat."

Her take-no-prisoners rule gets results. She doesn't miss appointments, she never forgets a pill. Tests show both children improving every day.

"Mom, I love you with all my heart and soul," JaVeda wrote in a Mother's Day card. "Don't think a day that I don't... you are my mom... who took me in when I was a baby."

"May your Easter be blessed with love, Mom," wrote Kenneth. "I know I've been messing up but it's going to get better. I need these three things: Love, Patient, Care."

"Every day is different," Linda says, stroking Kenneth, who sits close. "Some days it's peaceful. Some days..."

She doesn't finish the sentence. Instead, Linda shrugs her shoulders and flashes a quick half-smile.

Luz & Her Mother

"It's Kind of Fun"

Luz Rodriguez is a soft-spoken, friendly Puerto Rican woman. Her home is crowded with her husband, four of her five grown children, and three visitors, plus her 89-year-old mother, Lucia Garcia.

When asked what it's like taking care of Lucia, who has asthma, a thyroid condition, and Alzheimer's disease, Luz smiles brightly and says, "It's kind of fun."

Luz pauses to consider. "It's not really that tough because my mother is so independent. She's smart, and when she forgets something, I help her remember. My children help me take care of her."

Upstairs, Lucia has made a home out of her bedroom. She dislikes taking the stairs down to the first floor, so she has stocked her room with food, a refrigerator, a television, profuse decorations, and, most important to her, hundreds of photographs of her extended family.

Lucia is talking rapidly in Spanish, describing the people in each photograph on her bed in detail, and there are several dozen photos. The translator is working hard to keep up with Lucia's verbal onslaught.

"This is my granddaughter," she says, pointing to a girl in a picture, "and this is her son, my great grandson. I love living in Milwaukee. I've been here more than 20 years. I get up early each day to take the bus to the Guadalupe Center, where I visit with the elderly. I love to sew there. I sewed that bunny up there," she points to a stuffed animal, "and that dress, on that doll there," she points to the dress on a doll. "If you go to the Center, you might see what I sew. The items are on sale for $7 each."

"It is fine being taken care of by my daughter. I'm happy. But, if I have to die in Puerto Rico, I will go there. My family needs me there. My husband is buried there."

Lucia turns on a CD player and begins to dance with energy and precise rhythm to the Puerto Rican music. She shouts with ecstasy. "Tell the people in the book that I am a hard worker. And if someone is bothering to me, I take a rock and send it at them, saying 'this is for you.'" She mimes the throwing of a rock, then continues dancing and smiling.

Luz was right: "It's kind of fun," indeed.

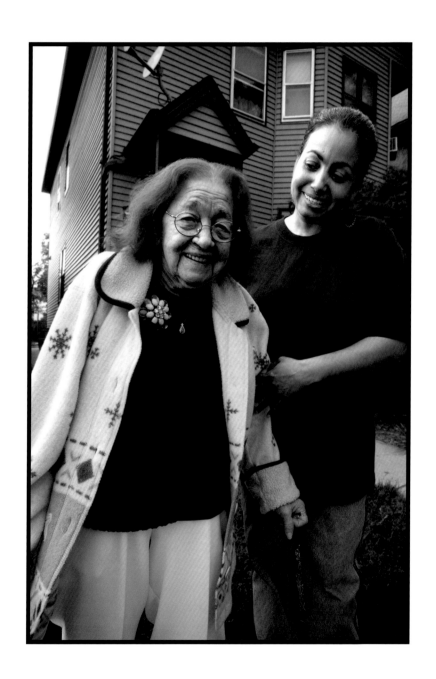

Ruth & Tom

Engaged

Ruth Ann Cross was a widow and a retired radiology assistant when, in the summer of 2004, she moved into a new apartment.

Tom Harris was divorced and a semi-retired teacher, photographer and jazz musician – he plays the drums – when Ruth Ann moved into his building.

Ruth was in her early 60s. Tom was in his early 70s. They'd chat from time to time. Ruth was lovely and knew all about music. Tom was handsome and sophisticated. He invited her to his apartment for some homemade chicken soup.

"I enjoyed it," she says.

And so: Romance. A year after they met, Ruth and Tom were engaged.

Tom developed blood vessel disease and needed a caregiver for three hours a day, five days a week. He is a very particular man, especially when it comes to people. In the fall of 2005, Ruth took the training she needed to become Tom's caregiver, which seemed like an ideal solution.

Friends are one thing. Lovers are another. A caregiver and client are something else again.

Weekdays, from 9 a.m. to noon, Ruth has a professional relationship with Tom. He didn't know what to make of this. Who was she to tell him how much salt to put on his food? Who was she to tell him he couldn't leave her alone in the house when she was on duty?

"I fired her," Tom said. "I would fire her all the time."

Ruth still wears her engagement ring. And she's still Tom's caregiver – at least at this writing she is.

"But we are not going to get married," she said. "I love him, but I can't live with him, and that's an absolute fact."

"She's my girlfriend and my caregiver," Tom said. "Today."

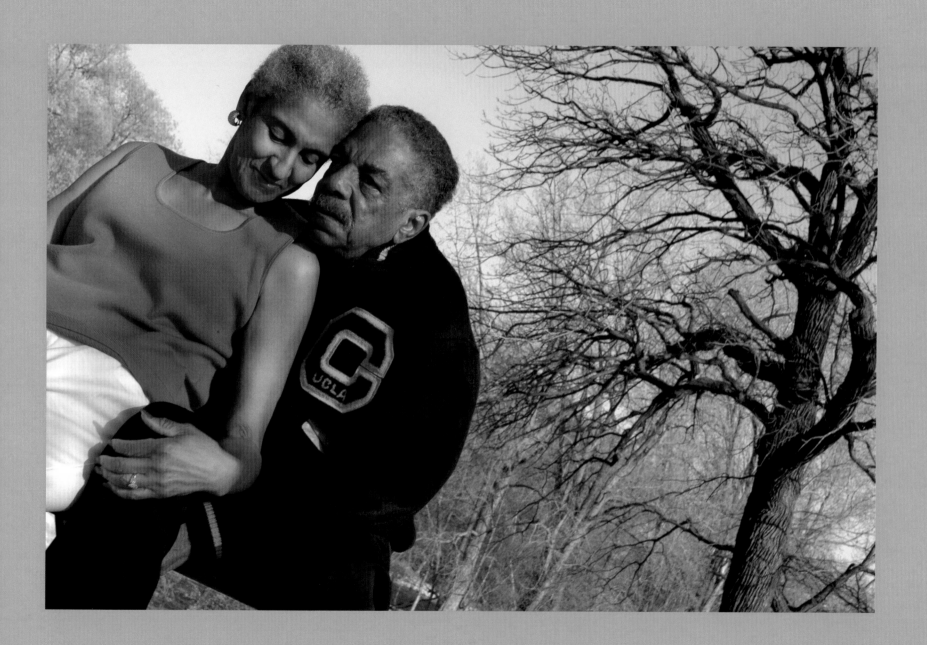

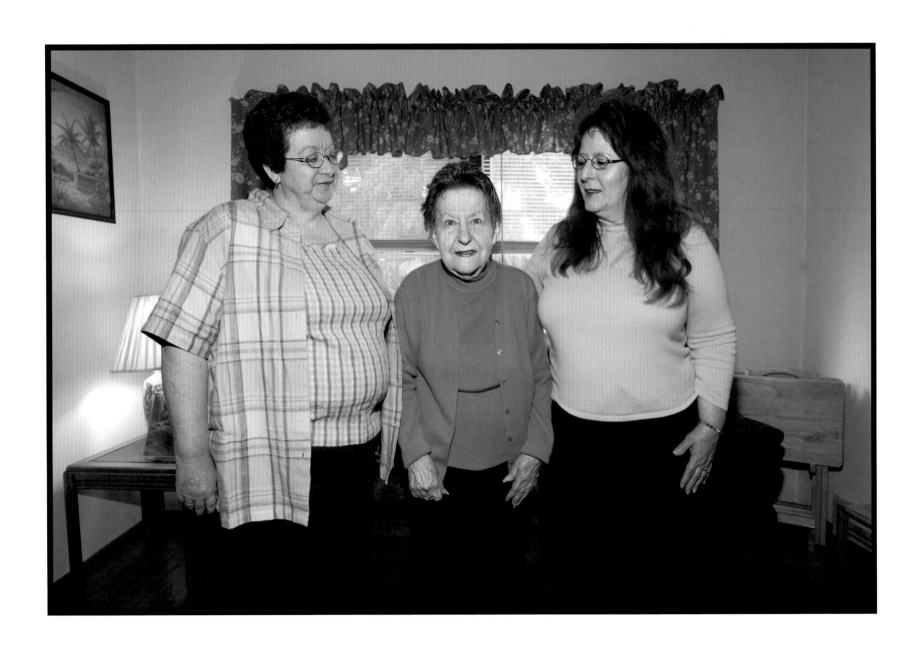

Margie, Mickey & Rose
"It's All Worth It"

This she knew: There would be days when it would be too hard. The sudden falls, the frustrated outbursts, the same questions over and over, the aimless wanderings.

Michaelene ("Mickey") Frank knew about all the tiny losses that are part of the long, slow slide into age and out of memory. A nurse and aide since 1976, Mickey has helped many others as they approached the tunnel of dementia.

Because Mickey understood what was inside the tunnel, she told her friend, Margie Zellner, that she was ready to help her at any time.

Margie had only an inkling of what was ahead when she asked her mother, Rose, then 83, to live with her.

Rose had had a stroke, which affected her left side. Margie marvels at her mother's ability to bounce back: "You'd never know she'd even had a stroke."

Rose stands with her arms in the air to show the extent of her recovery. She is 4-foot-10½, with a slight stoop, her dark brown hair neatly brushed in preparation to meet her visitor. Her smooth face looks like it belongs on a 40-year-old.

"See?" Margie says. "She's amazing."

"I call her 'my favorite Rose,'" Mickey says.

Rose smiles at that.

"I'm young for my age," she says. It is the definitive conclusion to a long-thought-about theory. "A lot of old people are old for their age. I'm not."

But no one can bounce back from time. With each step Rose took into the tunnel, her daughter gave up something.

First, it was her job at Kmart – next, her sense of security. Margie installed a door alarm to keep her mother from wandering outside.

There are moments of tenderness: Her mother's short-term memory loss means "She thanks me 50 times a day. She's so gracious."

But Margie's nerves frayed more everyday. It was time to accept Mickey's offer.

Once a week Mickey takes Rose to dinner or they watch old movies together. "I try to make it a special time just for us," Mickey says.

Margie, meanwhile, has four hours to do as she pleases. Sometimes she goes to bingo because, "All you have to worry about is what number is coming next."

"Yes, your time is limited." Margie sighs, reflecting on her life now with Rose, the woman she loves most in the world. "But when I put her to bed at night and she says – I'm going to get emotional – when she says, 'Oh Margie, I love you so much, no one else but you would care for me like this,' it's all worth it. It is all worth it."

Vincent, Ariel & Their Mom

Counting on the Kids

Early in her treatment for lupus, Ann Marie Glaviano, a single mom, was so fatigued that she came downstairs exactly twice a day: once to make breakfast and once to cook dinner.

"We lived in a townhouse with 15 steps up and 15 steps down, but the kids had to do all the running," she said.

Now, even on good days, she depends on her two teenage children for help. Lupus – a chronic autoimmune disease – attacks her joints, kidneys and blood cells, and the medication that treats it leaves her with little energy.

Vincent, 16, shares cooking duties with his mom – omelets are his specialty – and Ariel, 13, is learning. Vincent also walks or bikes to the grocery store, does laundry and mows the lawn. Ariel, who splits time living with her father and mother, feeds and cleans up after the family cats, birds and fish when she's at Ann Marie's.

"It really reverses roles and makes them realize how much you count on them," Ann Marie said.

But those roles have a price. The Glaviano family was part of an "NBC Nightly News" report about young caregivers and the negative effects of taking on responsibilities beyond their years.

A recent study issued by the National Alliance on Caregiving and the United Hospital Fund found that children who provide substantial assistance to ill relatives or household members are given jobs that can interfere with homework in the short term and disrupt emotional development in the long term.

When chemotherapy treatment forced Ann Marie to stay in bed, Ariel got angry at her, said Ann Marie, who was diagnosed in 2000.

"Ariel told me, 'I can't even stand the sound of your voice sometimes' – because that's the voice that would call from the bedroom," she said.

Vincent said he picked up his mom's housework and some of her parenting work, all while getting outstanding grades in school.

"Sometimes when stuff like this happens, you just want to escape sometimes," he said. "But you can't because it's your home."

A pilot program in Boca Raton, Fla., is starting to support young caregivers by building their caregiving skills, giving respite from their duties, and connecting them with additional resources. Organizers hope the project becomes a model for similar programs nationwide – and so does Vincent.

"A program like that would've cut down on a lot of insecurity that I have faced," he said.

He's used to juggling his dual role as son and caregiver. He said he does it by "choosing to be stubbornly optimistic."

"I can be upset about it and get nothing done, or work on it and ... try to succeed. It's a difference between thriving and surviving, and I choose to thrive."

• STORY AND PHOTO ON FACING PAGE REPRINTED WITH PERMISSION FROM THE NAPERVILLE SUN

PHOTO: COURTESY OF THE FAMILY

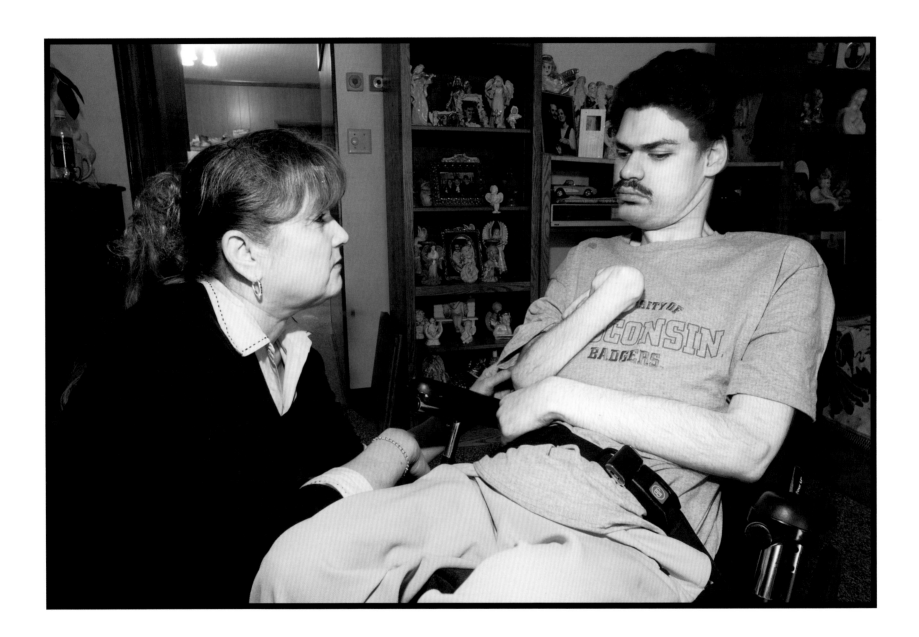

Miguelina & Tony

"I Had to Relearn How to be a Mother"

"I think I know Tony better than anyone else," she says.

"I know him like I know the palm of my hand. He is unable to speak, but I know. I anticipate his needs. He needs to eat. He needs my attention. He needs to be spoken to."

"He is not a burden to me," she says.

"I love him so much. He is a part of me."

Miguelina Busalacchi is Tony's mother. She is 60 years old. Tony is 30. In 30 years, Miguelina has been away from Tony perhaps a total of a month. A few hours here. A few hours there. One day a year for 30 years.

Tony is Miguelina's third child. Her daughter and her other son are older than Tony. Miguelina brought Tony in for a check-up when he was six months old. The doctor told her: "You have a normal, bouncy baby."

Tony began having seizures the next day. At one point, he had 60 seizures in a single hour.

Tony has cerebral palsy. He is blind and cannot speak. He is paralyzed in all his extremities.

"To have a child like Tony is difficult," says Miguelina. "After two healthy children, I didn't know what to do."

"At first I didn't treat him like a normal person. I treated him like he would break. I had to relearn how to be a mother. I had to learn to be a better mother."

"Tony has taught me so much. He has taught me to be kind and loving. He has made me a better person."

"It offends me when people ask 'Is he a burden?' He is not a burden to me. He is a blessing in my life."

Clyde & John

"Having the Heart to Listen"

They first met because of a failed babysitting session. It was no one's fault; it's just that Clyde's step-sister couldn't find a way to connect with John, then a curious child of 8.

Clyde Kipcak, who was 12 at the time, had no experience with people with autism. But he had plenty of experience being a boy.

As it turned out, that was what John Colston needed most. Clyde talked to John about plain old boy stuff: Godzilla, Pokemon, cartoons.

"It just seemed like I could get a better connection out of John than other people," says Clyde, surprised himself at the success of the simple strategy.

That early connection established on the foundations of boyhood six years ago has grown into a significant friendship strengthened by regular visits during the school year and daily visits in summer.

But Clyde's friendship with John hasn't sparked ambitions about a career as a caregiver.

"My connection with John is very personal and individual," Clyde says. "I don't think I could do it for my regular day job."

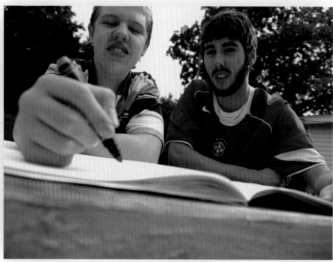

They find in each other someone who is absent or only faintly near in their lives: Clyde gets a younger brother in John; John gets an older brother and, sometimes, a father, in Clyde.

John has taught Clyde much about how the mind works, about patience, about how there are many paths to learning.

"You can look at people and see that they are different – in race or ethnicity – but it's hard to learn about someone who is different mentally," Clyde says. "You come to understand intrinsically how it works."

John isn't one to reflect for long on his relationships with people. Rather, he expresses himself through intricate drawings, caricatures, cartoons and in mini-sculptures.

John rarely spends more than a few seconds on his art, but earlier this year, he drew a portrait of Clyde that impressed everyone. The detail and care John put into the work were a measure of how much he thinks and cares about one of the most important influences in his life.

Sarah, John's mother, has found Clyde's presence a revelation.

"It's neat to see Clyde getting insight ... to see him having the heart to listen," she says. "I don't know that we live in a society that rewards enough of that. We seem to be living in a society that rewards people who don't have the time."

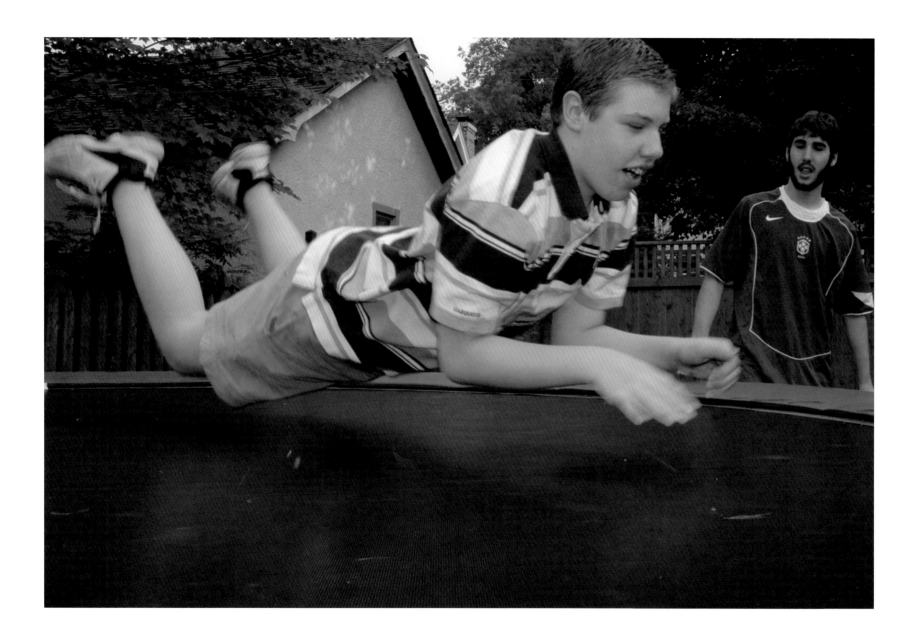

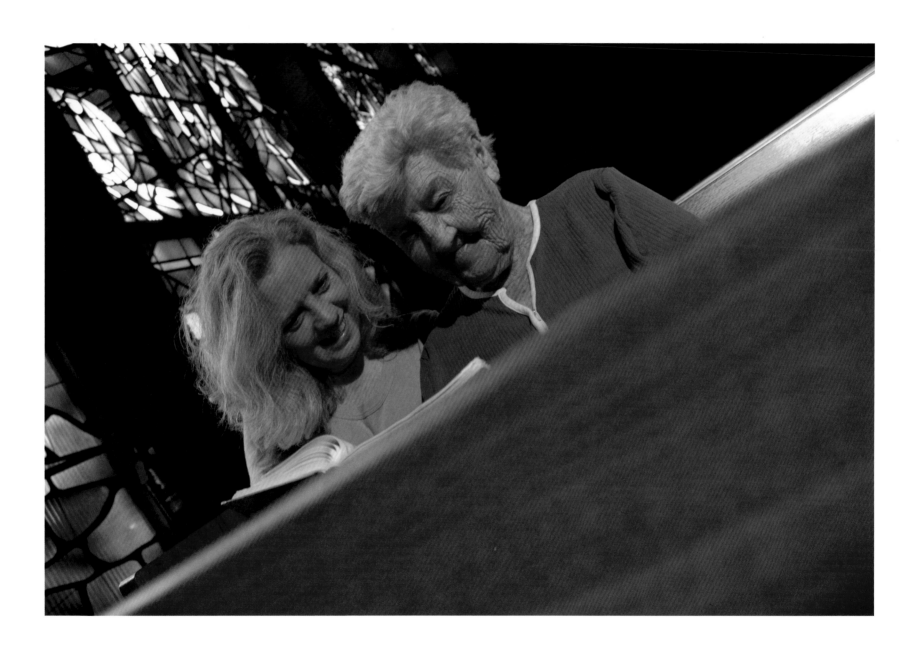

Wendy & Her Grandma

Wendy's Journal Entry

My Grandmother lives with me. She is 94 years old, nearly blind, mostly deaf, and she has dementia.

She has been a soulmate, really. We have had tea parties with every animal and dolly I could muster up. We have explored any number of craft mediums in our 41 years of being Grandma and granddaughter. We have shopped together. Traveled together. Prayed and gone to church together. We laugh and cry at the same things. At least, we used to. I can't imagine a better family relationship or one more soundly rooted in faith than the one we have shared.

That has all seemed to fade, to have gotten swallowed up by this process of whatever is happening to her brain, which I do not understand and I do not like. For the first time in my life, it is difficult for me to be with my Grandma 24 hours a day.

The things that pop out of Grandma's mouth, some of her odd behaviors, are intriguing, in a mysterious/educational fashion. My brain reminds me this is a disease process. But my heart breaks every time Grandma is upset with me or accusatory of something that has never happened.

Her night persona is different from her day persona, and at night time Grandma is downright scary sometimes. She's so grouchy and she's never been that way with me. It hurts even though I know she has no idea she is acting the way she is. I am exhausted and I miss my Grandma and I want to sleep in – just one morning.

How selfish of me. Or is it? I am such a perfectionist and so stubborn and determined, I am not the type to ask for help. But I am asking. Maybe I haven't asked for help in the right way.

One person was honest enough to tell me they don't like to call because they are afraid I might ask for help. They are not comfortable helping and do not know what to do. Come over and wash the dishes, maybe? How about bringing a meal once a week? Or, running for Grandma's care supplies? How are those for suggestions?

What is the lesson in all of this, God? I know who's who in my life now.

You have revealed Yourself through my mom who has come during an emergency at 3 a.m., after working a 12-hour shift. You are there in the caring hearts of my in-laws, who have gone through this and know the depths of what I am facing. I know, too, You are working my husband, helping him to try to help me as best he can.

You are the reason I can pull myself out of bed after a busy night filled with tasks sometimes too yucky to describe. You are the reason I can walk with my eyes open and not fall over.

And that occasional glimpse of Grandma – that is You too, isn't it? Her look of determination when folding towels for me, that look I remember so well as she bustled around her cottage doing thirteen things at once. Her few and far between attempts at interacting, usually asking, "Dean working late tonight?" That is still You living in my Grandma, who is a stranger, yet familiar.

I feel blessed to have this opportunity to care for the woman who has directed my life, and others' lives, so dramatically.

Lesson learned, God. Please continue to send the support and strength that is needed to see us through. Amen.

Maseline & Alice
"It's Wonderful"

Maseline Albring stands rooted like a hearty tree in the living room of her friend Alice Cornejo, faces a visitor with forceful presence, and announces, "I am Maseline Albring."

Maseline was born in 1932, and carries her maturity like a halo. Her voice is deep and strong, full of rich character. She met Alice, a fellow Native American, in 2001, as a participant in a Senior Companions Program, but the two have become "like sisters," according to both of them.

"So, what do you want?" she asks the interviewer, peering at him through clear eyes.

How about sharing the story of this friendship?

"Well, I found retirement boring," Maseline says. "Just sitting around wasn't for me. So I got involved with the Companions Program. I started going to meals with Alice and the Indian Council of the Elderly. I didn't think I'd care for being with a bunch of old people, but it's wonderful."

Alice chimes in, "Maseline is older than me. But I was the one who couldn't get around well after my coronary bypass surgery. I had to use a cane. We're dear friends now, like family. We go to lunch together, shopping, to Potawatomi Bingo Casino and sometimes even up to the casino in Green Bay. We go to parties, and movies, and Maseline takes me to the doctor. I have gout, diabetes, arthritis, especially in my legs, high blood pressure, and coronary artery disease."

"But," Alice smiles, "one of these days my friend here and I are going to go dancing. Sometimes, I feel a little rough, but I keep myself going, and my friend here says, 'Come on, let's go.'"

Maseline, who helps not just Alice but five other elderly Native Americans in her work with the Indian Council of the Elderly, proudly displays her Wallace Pyawasit Community Leadership Award. The award is named for a beloved Menominee tribal leader. Maseline also shows her visitor a newspaper article noting her receipt of the Pyawasit Award, and another plaque recognizing her devotion to fitness.

"I exercise," Maseline says. "From the moment you're conceived, you're exercising. When you're just a pollywog, you're moving around. The Great Spirit is already preparing you to take care of yourself. You must keep moving. It's very important."

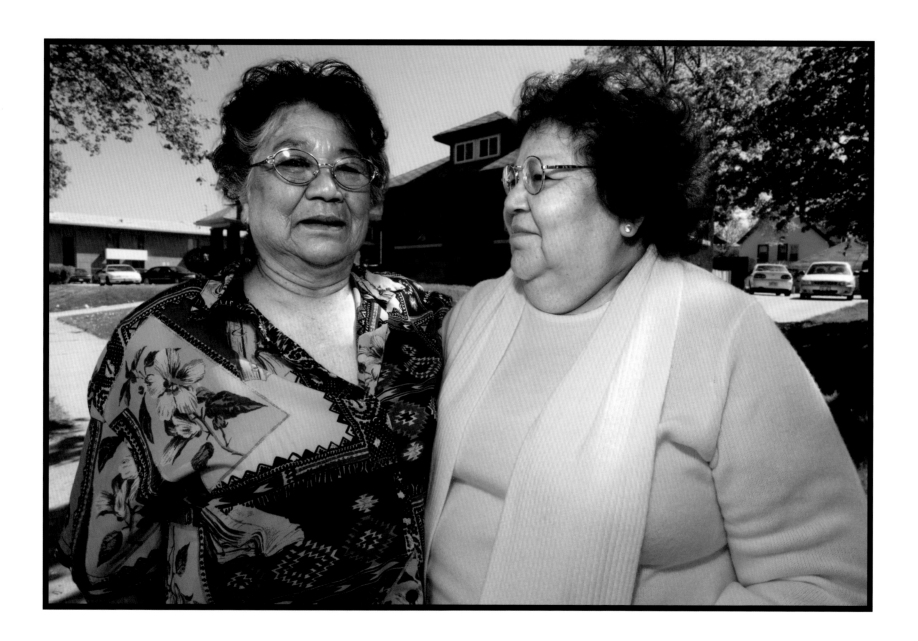

Rob, Jane & Drew

"Why Wouldn't We Care for Him?"

There will come a time when Rob Phillips will be the last one standing, the only caregiver to his son and his wife.

He knows it, accepts it, even talks about it on occasion. But he doesn't dwell on it.

"It's scary," he says.

"Very scary," his wife Jane adds.

She glances at the affable, blue-eyed man sitting beside her. She has a way of looking at her husband that both gives and gets support.

They have been in the fight so long together, meeting all challenges, it is strange to think of him doing it alone.

"We didn't choose this," she says. "But you handle it."

Their 19-year-old son Andrew ("Drew"), has a severe neuromuscular disorder inherited from Jane, who has a milder form of it.

No one can pinpoint Drew's precise problem, which makes his condition harder to treat. Cognitively, Drew is around 5 years old. He is perpetually dehydrated. His immunity is poor. His kidneys are weakening. A couple of years ago his gastrointestinal system came to a stop.

And he's getting worse, Jane says: "Ultimately, he'll be like the bubble child."

Last year, Drew wound up in intensive care "with every bacteria and yeast infection you could think of," Jane says.

That night, their son couldn't stop sobbing.

"There's pain," she says. "And then there's suffering."

Drew's situation is tough, but the couple's battles to get acceptance and respect for their son are the toughest: the hospital red tape every time they bring in Drew, a patient "who's been there more than God," as Rob puts it; the insistent "suggestions" they put Drew in palliative care; questionable and spotty special education programs; even the restaurant hostess who sat them in the darkest part of the dining room as if to protect the other patrons from Drew.

Meanwhile, Jane's health deteriorates. Already small, Jane has lost 30 pounds in recent months. She was rushed to the hospital once with adrenal failure.

"Eventually, it'll just be me" caring for them both, Rob says. He'll take on the duty gladly, just as he and Jane did for Drew.

They know people who have given up, walked away, put their children in institutions. Jane and Rob won't do that.

"He is our son, OK?" Jane says. "That is number one. Why wouldn't we care for him?"

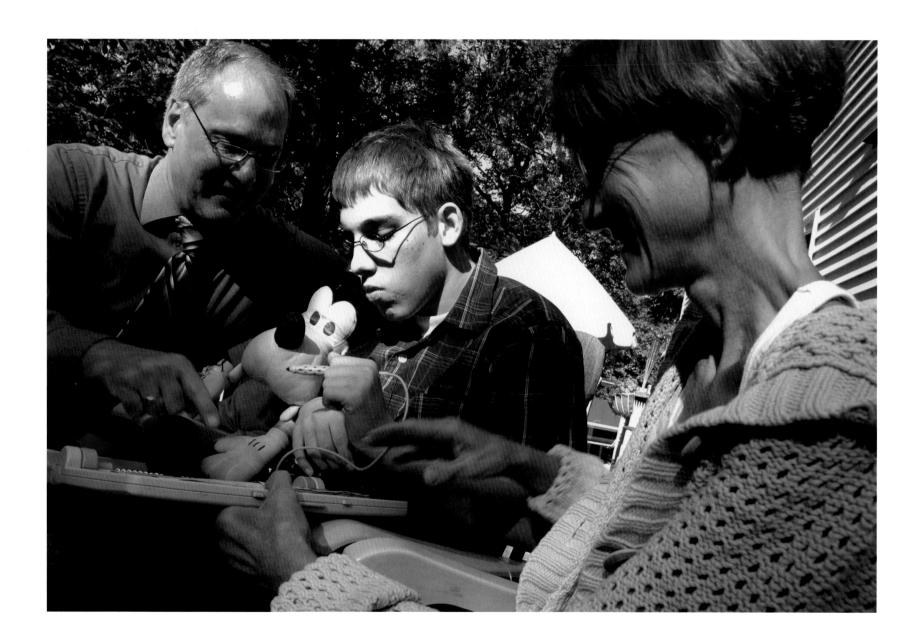

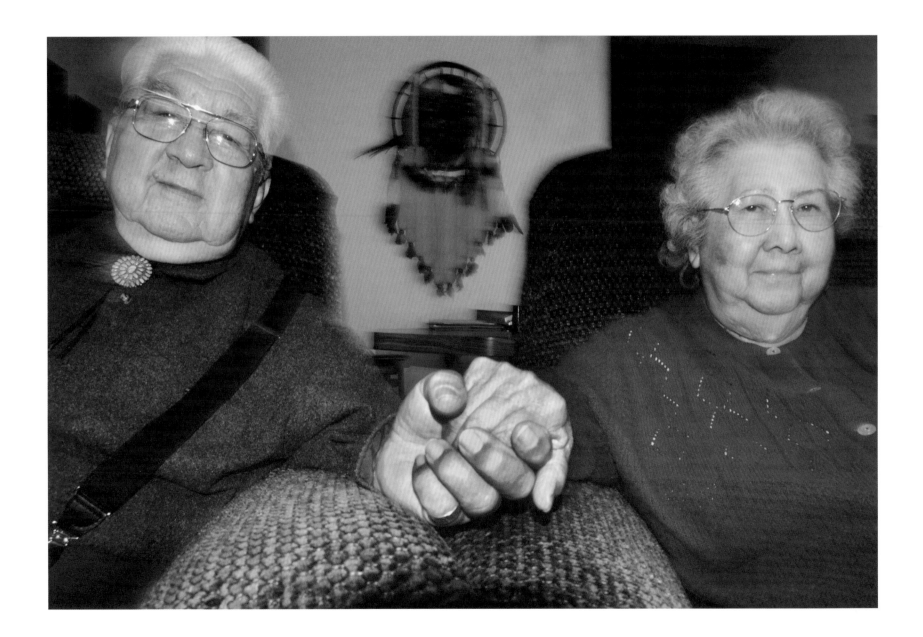

Roy & Alice
In Sickness and in Health

Roy Huff came home from the war that winter: January, 1946. There was a blizzard that day. Snow covered the road he followed to his home on the Oneida Reservation in Wisconsin. He drove over the road, setting down fresh tracks.

As soon as he could, he went to see Alice Baird. They had known each other since childhood; he was two years older than she. They married that summer, on July 18th, on the reservation at Holy Apostle Episcopal Church. It was so hot that they spent the afternoon at a movie theater, cooling off.

Sixty years ago.

That day, they had promised: for better or for worse, for richer or poorer, in sickness and in health. They promised to take care of each other, husband and wife.

Today, Roy and Alice share a small apartment in the Milwaukee suburb of Greenfield. They have six children, seven grandchildren and two great grandchildren. Roy retired from the U.S. Postal Service in 1989. He and Alice traveled a little, but

Alice's diabetes worsened, and Roy didn't like to go off somewhere without her.

Alice goes in for dialysis for three hours a day, three days a week. Roy takes her to her appointments, picks her up afterwards, and runs errands in between. He takes care of her. She takes care of him.

Roy knows there are more days behind them than there are days ahead. But that's okay. He knows that the days ahead are uncertain – they are both old. But that's okay. Whatever lies ahead, they will face it together, taking care of each other as best they can.

In the morning, when Roy wakes up, the day ahead is like the snow-covered road he followed home from the war. A new day. He and Alice will travel that day's road together, setting down fresh tracks.

Andrea, Pedro & Their Children
Multiple Challenges

When their daughter Adriana was born with cystic fibrosis, Andrea and Pedro Garcia were baffled. The lung disease is hereditary, but both parents must have the gene to pass the condition on to their child. Neither knew anyone in their families who had had it.

Four years later, their son Pedro Jr. contracted bacterial meningitis ten days after his birth. The couple prayed he would live.

"Then you find out about all the problems," about what lies ahead, Andrea says. She regards her son, now five, who sits nearby in his wheelchair. Pedro Jr. is humming gently, a clear sign that he's in a good mood.

"That's tough," Andrea says quietly.

Pedro Jr., or "Gordo" as the family affectionately calls him because he's pudgy, has developmental disabilities and is virtually blind. He can detect color and can occasionally see objects peripherally.

At 77 pounds, Gordo is a handful. Andrea hopes recent surgeries on his legs and a diet to curb his weight will help him to learn to walk. Different therapists couldn't agree on how to proceed with Gordo's treatment when he was smaller, which meant they missed early opportunities to teach him to walk.

Nine-year-old Adriana, meanwhile, needs a diet rich in fats and proteins. Twice a day she wears a special vest which helps to break up the mucus. The device vibrates and exerts pressure on her chest.

"I talk funny when I wear it," Adriana says.

Andrea smiles, then considers her family's challenges. Having children with extreme health needs brings you in contact with others who have similar, sometimes worse, lives, she says.

Andrea was born in Ohio, a third-generation Mexican-American. She is bilingual and skilled at navigating the dizzying maze of local, state and federal agencies that help her keep her kids well. Her husband Pedro shares many of the child-rearing duties, which is uncommon in Latin culture, Andrea says.

When she compares her situation with that of less savvy, monolingual Hispanic women who have children with disabilities, Andrea feels both fortunate for herself and frustrated for those forced to suffer in silence.

"I've encountered a lot of Hispanics who have disabilities and they don't really have a voice," she says.

It has prompted Andrea to go back to school and to possibly enter the medical field, with the goal of helping some of those silent women.

"It is hard enough for us," she says. "It is so much harder for them."

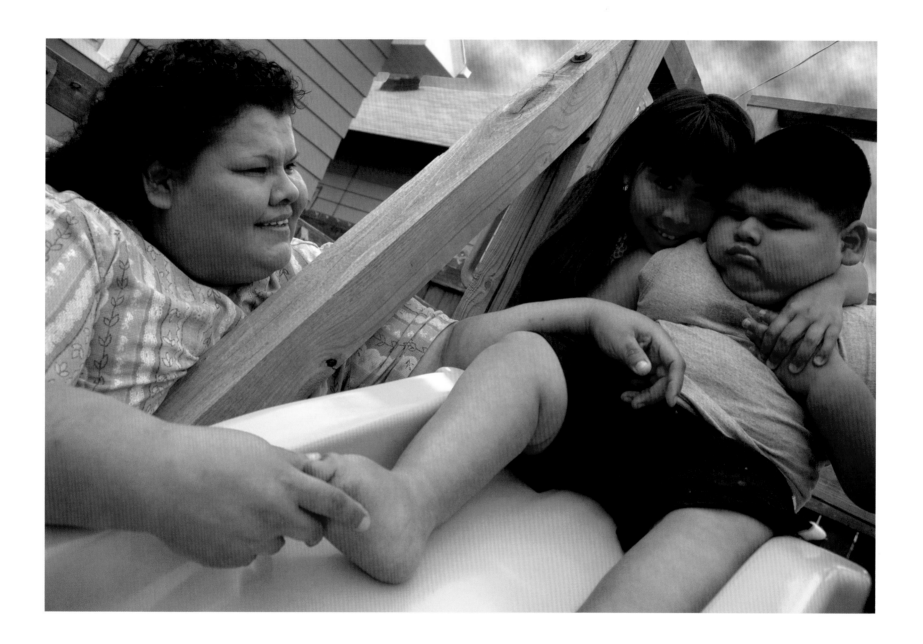

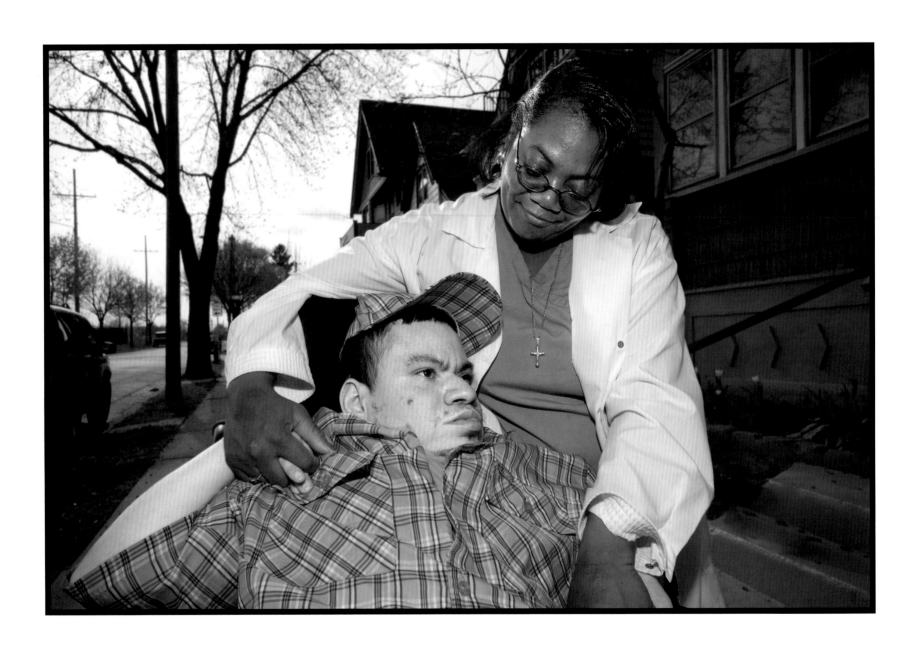

Ann & Davey
A United Family

When Ann Gray became caregiver for Davey Lombrano ten years ago, she didn't know she was taking on an entire family, but she was.

Ann is the paid caregiver, but she works on a team with the rest of Davey's family, including his energetic and outspoken mother Oralia, his devoted stepfather Eddie, seven brothers, one sister, and, at last count, two nieces. They all pitch in on a regular basis. Davey, who has spina bifida and Down syndrome, has an extensive support network, to say the least.

"Everybody works with Davey," says Oralia, as Davey, 35, sits in a wheelchair between Oralia and Ann. "My children don't know any other life."

In the living room sits Davey's brother Elias, and sister Evelina, with his nieces Mari and Sefie nearby. Ann blends in seamlessly with the throng.

"I work for Davey from 6 to 9:30 a.m.," Ann says, "and from 2:30 to 5:30 p.m., every weekday, plus every other weekend. Davey's family handles his care the rest of the time, around the clock. I do bowel movement extraction, push on the bladder for urine release, and feed him by hand. I help him avoid body sores by giving him range of motion exercises, and by washing him thoroughly two or three times a day. He has skin like a baby."

"I'm his legs and I'm his mouth," says Oralia. "He's my baby. We will not put him away in any facility or home until the Lord calls him home. He was just an innocent baby when diagnosed. Why should it happen to him? I was totally devastated. But, Davey has united this family tight."

Oralia has a message she'd like to convey: "Davey's condition is nothing to be scared of, or ashamed of. It's not a person's fault they're ill, so they're entitled to the same compassion as anyone."

"Also," she adds, "no one can handle this sort of situation alone."

Evelina and Elias are asked if they'd like to convey any message.

Evelina says, "Like my mother says, don't be ashamed. We were teased in childhood, but learned to not be embarrassed."

Elias says, "I go to a prestigious school. I hear rich kids complaining about situations in their lives. But people don't know what harsh really is until they experience something like this."

Ann concurs with Davey's family, which, over the years, has become her own as well.

Clarice & Her Family

"I Made a Promise to the Lord"

Older people do a lot of caregiving for elderly family members and friends. Among Americans 75 and older, one in five say they do some caregiving. And sometimes it's the very old who help out – like Clarice Morant. She's 101.

In Clarice's small and tidy living room, photographs of family crowd the walls, tables and shelves. Clarice coaxes her elderly brother, Ira, to get up off the couch for lunch.

Ira can't speak, as the result of a stroke. He's a handsome man sharply dressed in gray pants and matching shirt. Just a few steps away is the dining room table. At the head of the table there's a plate of chicken, collard greens and macaroni and cheese.

Clarice can't get her brother to pull himself up on his walker and take those few steps to the dining room. "Your dinner will get cold if you don't eat now," she tells him. "Come on, honey. Come on, eat something."

Clarice lives in her brick row house with her brother and her sister, who's in the next room, in a hospital bed. Her sister, Rozzie, is 89. Her brother is 95. And Clarice, who cares for them, is 101. …

Clarice cooks for her brother and sister. She does their laundry, bathes them and gets up in the night to turn and change them. She's a small woman. But she stands up straight. Her friends and family don't call her by her given name, they call her Classie.

According to a study by the Urban Institute, people 75 and older provide more hours of caregiving than people in any other age group.

After her husband died, Clarice moved into this house, which belongs to her sister. Rozzie, her sister, is blind and in the terminal phase of Alzheimer's disease.

"I've been taking care of my sister for 20 years, and my brother for about six now," says Clarice.

Clarice and her siblings all sleep just steps away from each other.

"Well, I don't get too much sleep," says Clarice. "Some nights I sleep more than others. Some nights, I don't think [Rozzie] feels too good. She's restless. She's making noises. She'll call me. Either one of them makes a noise, I hear it."

Government programs, family and friends help them get by.

On weekdays, Clarice gets important assistance from in-home aides. One comes three hours on Monday, Wednesday and Friday to care for her sister. Another aide cares for her brother, 12 hours a day, Monday through Friday.

But at night and on Saturdays and Sundays, Clarice is on her own, the lone caregiver for her sister and brother.

Clarice says there's a simple reason why she does the hard work of caregiving: "I made a promise. To the Lord. If he gives me the health, the strength, the life to do for them. Take care of them; keep them from going in a home. I would do it. And as long as he gives it to me, I will give it to them."

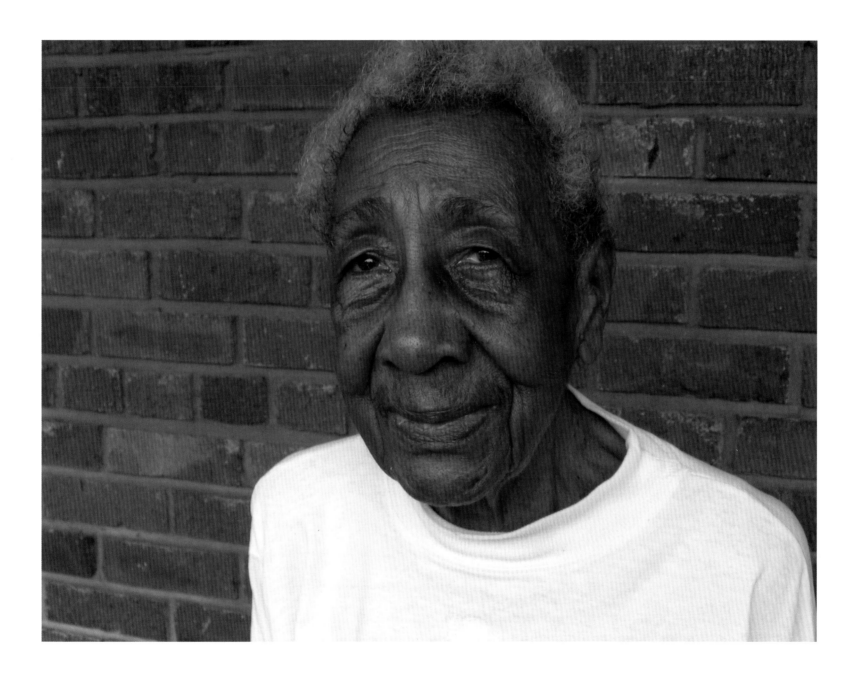

Caregiver *Resources*

American Association of Caregiving Youth
3998 F.A.U. Blvd., #307
Boca Raton, FL 33431
Voice: (561) 391-7401
www.aacy.org

The mission of the American Association of Caregiving Youth (AACY) is to recognize, support, and promote the awareness of dual role youth who are both students and caregivers within their families. AACY strives to address the needs of pre-teens, teens, families, and professionals through education and awareness, research, and direct services in cooperation with social, education, healthcare, government, and community corporations, organizations, and agencies on a local, regional, and national level.

ADAPT
201 S. Cherokee Street
Denver, CO 80223
Voice: (303) 733-9324
Email: adapt@adapt.org
www.adapt.org

ADAPT is an activist organization with an informal structure. To become involved you must be interested in changing the longterm care system, getting individuals out of nursing homes and other institutions and getting people attendant services in the community. The key word is active. Each local ADAPT group develops its own style and structure with decisions usually made by group consensus. While each group has local issues they address, all work on ADAPT's national attendant services campaign which is seeking to have 25% of Medicaid long term care funds redirected to pay for a national, mandated attendant services program. Call or visit the web site to find the chapter nearest to you.

American Association of People with Disabilities
1629 K Street NW, Suite 503
Washington DC, 20006
Toll–free: (800) 840-8844
V/TTY: (202) 457-0046
www.aapd.org

People with disabilities in America are over 50 million strong. AAPD is a membership organization of people with disabilities and their families that serves as a positive private-sector force to achieve the goal of full inclusion for people with disabilities in American society.

National Alliance for Caregiving
4720 Montgomery Lane, 5th Floor
Bethesda, MD 20814
Email: info@caregiving.org
www.caregiving.org

The National Alliance for Caregiving is dedicated to providing support to family caregivers and the professionals who help them and to increasing public awareness of issues facing family caregivers.

National Clearinghouse on the Direct Care Workforce
349 East 149th St., 10th Floor
Bronx, NY 10451
Toll–free: (866) 402-4138
Email: info@directcareclearinghouse.org
www.directcareclearinghouse.org

The National Clearinghouse on the Direct Care Workforce is a national on-line library for people in search of solutions to the direct-care staffing crisis in long-term care. A project of the Paraprofessional Healthcare Institute (PHI), the Clearinghouse includes government and research reports, news, issue briefs, fact sheets, and other information on topics such as recruitment, career advancement, supervision, workplace culture, and

caregiving practices. The Clearinghouse also houses training manuals and how-to guides, a list of direct care worker associations and listings to other associations, resources, and events.

National Family Caregivers Association
10400 Connecticut Avenue, Suite 500
Kensington, MD 20895-3944
Toll–free: (800) 896-3650
Voice: (301) 942-6430
Email: info@thefamilycaregiver.org
www.thefamilycaregiver.org

The National Family Caregivers Association (NFCA) supports, empowers, educates, and speaks up for the more than 50 million Americans who care for loved ones who have a disability, who are chronically ill or who are aged. NFCA reaches across the boundaries of different diagnoses, different relationships and different life stages to address the common needs and concerns of all family caregivers. It is committed to improving the overall quality of life of caregiving families and minimizing the disparities between family caregivers and non-caregivers.

Center for Personal Assistance Services
Department of Social and
Behavioral Sciences
School of Nursing
University of California
3333 California Street, Suite 455
San Francisco, CA 94118-0612
Toll–Free: (866) 727-9577
Voice: (415) 502-7190
TTY: (415) 502-5216
www.pascenter.org

The Center for Personal Assistance Services provides research, training, dissemination and technical assistance on issues of personal assistance services (PAS) in the U.S.: 1) the relationship between formal and informal PAS and caregiving support, and the role of assistive technology (AT) in complementing PAS; 2) policies and programs, barriers and new models for PAS in the home and community; 3) PAS workforce development, recruitment, retention, and benefits; and 4) workplace models of formal and informal PAS and AT at work.

Rosalynn Carter Institute for Caregiving (RCI)
800 GSW Drive
Georgia Southwestern State University
Americus, Georgia 31709-4379
Voice: (229) 928-1234
Email: rci@canes.gsw.edu
www.rosalynncarter.org

The Rosalynn Carter Institute on Caregiving (RCI) works to establish local, state and national partnerships committed to building more effective long-term care systems and providing greater recognition and support for America's unsung heroes – the millions of caregivers, both family and professional, who provide us all with models of selfless service and hope for the future.

ADDITIONAL RESOURCES ON
DISABILITY AND INDEPENDENT LIVING:

Americans with Disabilities Act Home Page
www.ada.gov

Comprehensive site with links to the full text of the historic ADA, frequently asked questions, ADA regulations and technical assistance manuals, standards for accessible design, regional ADA and IT Technical Assistance Centers, enforcement agencies, and more.

ADA Information Line
Voice: (800) 514-0301
TTY: (800) 514-0383

Call toll-free to obtain answers to general and technical questions about the ADA and to order technical assistance materials.

www.DisabilityInfo.gov

DisabilityInfo.gov is a comprehensive online resource designed to provide people with the information they need to know quickly and easily. With just a few clicks, the site provides access to disability-related information and programs available across the government on many subjects, including benefits, civil rights, community life, education, employment, housing, health, technology and transportation.

National Council on Independent Living
1710 Rhode Island Ave, NW, 5th Floor
Washington, D.C. 20036
Voice: (202) 207-0334
TTY: (202) 207-0340
Email: ncil@ncil.org
www.ncil.org

The National Council on Independent Living (NCIL) is the oldest cross disability, grassroots organization run by and for people with disabilities. NCIL advances independent living and the rights of people with disabilities through consumer-driven advocacy. Founded in 1982, NCIL represents over 700 organizations and individuals including Centers for Independent Living (CILs), Statewide Independent Living Councils (SILCs), individuals with disabilities, and other organizations that advocate for the human and civil rights of people with disabilities throughout the U.S.

World Institute on Disability
510 16th Street, Suite 100
Oakland, CA 94612
Voice: (510) 763-4100
TTY: (510) 208-9496
Email: wid@wid.org
www.wid.org

The World Institute on Disability (WID) is a nonprofit research, public policy and advocacy center dedicated to promoting the civil rights and full societal inclusion of people with disabilities. WID's work focuses on four areas: employment and economic development; accessible health care and Personal Assistance Services; inclusive technology design; and international disability and development.

Rights & Responsibilities

The following statements and policies relate to the rights and responsibilities of caregivers, carereceivers and agencies that provide caregiving services. These samples are drawn from a variety of sources, and can be used as models in the development of policies governing employment, service provision and quality assurance. We gratefully acknowledge each of the sources for permission to reprint the statements here. More samples can be found online.

I. A Caregiver's Bill of Rights

• Caregivers have the right to receive sufficient training in caregiving skills along with accurate, understandable information about the condition and needs of the care recipient.

• Caregivers have the right to appreciation and emotional support for their decision to accept the challenge of providing care.

• Caregivers have the right to protect their assets and financial future without severing their relationship with the carereceiver.

• Caregivers have the right to respite care during emergencies and in order to care for their own health, spirit, and relationships.

• Caregivers have the right to expect all family members, both men and women, to participate in the care for aging relatives.

• Caregivers have the right to provide care at home as long as physically, financially and emotionally feasible; however, when it is no longer feasible, caregivers have the obligation to explore other alternatives, such as a residential care facility.

• Caregivers have the right to temporarily alter their premises as necessary to provide safe and livable housing for carereceivers.

• Caregivers have the right to accessible and culturally appropriate services to aid in caring for aging carereceivers.

• Caregivers have the right to expect professionals, within their area of specialization, to recognize the importance of palliative (ease without curing) care and to be knowledgeable about concerns and options related to older people and caregivers.

• Caregivers have the right to a sensitive, supportive response by employers in dealing with the unexpected or severe care needs.

From The Caregiver's Handbook, edited by Robert Torres–Stanovik, LCSW, published in 1990 by Caregiver Education and Support Services, Seniors Counseling and Training Case Management Services of San Diego County Mental Health Services

II. Bill of Rights for Home Care Consumers

In 1993 the New Hampshire Legislature adopted a bill of rights and responsibilities for home health care consumers. All New Hampshire-licensed providers are required to abide by these rights. Medicare-certified agencies must comply with additional rights set forth in federal regulations, and those agencies that are accredited by an external organization like the Joint Commission on Accreditation of Healthcare Organizations (JCAHO) may have yet more requirements related to consumer rights.

Following are the minimum state-required rights and responsibilities for home care consumers in New Hampshire.

HOME CARE CLIENTS' BILL OF RIGHTS

I. Home health care providers shall provide their clients with a written copy of the rights and responsibilities listed in paragraphs II and III of this section in advance of or during the initial evaluation visit and before initiation of care. These rights apply only to the services delivered by or on behalf of the home health care provider. If a client cannot read the statement of rights it shall be read to the client in a language such client understands. For a minor or a client needing assistance in understanding these rights, both the client and the parent or legal guardian or other responsible person shall be fully informed of these rights.

II. The statement of rights shall state that at a minimum the client has a right to:

A. Be treated with consideration, respect, and full recognition of the client's dignity and individuality, including privacy in treatment and personal care and respect for personal property.

B. Be treated with consideration, respect, and full recognition of the client's dignity and individuality, including privacy in treatment and personal care and respect for personal property and including being informed of the name, licensure status, and staff position and employer of all persons with whom the client/resident has contact, pursuant to RSA 151:3–b.

C. Receive appropriate and professional care without discrimination based on race, color, national origin, religion, sex, disability, or age, nor shall any such care be denied on account of the patient's sexual orientation.

D. Participate in the development and periodic revision of the plan of care, and to be informed in advance of any changes to the plan.

E. Be informed that care is evaluated through the provider's quality assurance program.

F. Refuse treatment within the confines of the law and to be informed of the consequences of such action, and to be involved in experimental research only upon the client's voluntary written consent.

G. Voice grievances and suggest changes in service or staff without fear of restraint, discrimination, or reprisal.

H. Be free from emotional, psychological, sexual, and physical abuse and from exploitation by the home health care provider.

Bill of Rights for Home Care Consumers

I. Be free from chemical and physical restraints except as authorized in writing by a physician.

J. Be ensured of confidential treatment of all information contained in the client's personal and clinical record, including the requirement of the client's written consent to release such information to anyone not otherwise authorized by law to receive it. Medical information contained in the client's record shall be deemed to be the client's property and the client has the right to a copy of such records upon request and at a reasonable cost.

K. Be informed in advance of the charges for services, including payment for care expected from third parties and any charges the client will be expected to pay.

III. The provider has the right to expect the client will:

A. Give accurate and complete health information.

B. Assist in creating and maintaining a safe home environment in which care will be delivered.

C. Participate in developing and following the plan of care.

D. Request information about anything that is not understood, and express concerns regarding services provided.

E. Inform the provider when unable to keep an appointment for a home care visit.

F. Inform the provider of the existence of, and any changes made to, advance directives.

III. Agency Statement of Responsibilities & Rights

Independence*First*, a Center for Independent Living in Milwaukee, Wisconsin, operates a Personal Assistance Services Program that provides personal care workers for people with disabilities. Following are excerpts from the agency's statement of "Rights & Responsibilities."

1. To promote the independent living philosophy with the consumer (carereceiver) and the personal care worker.

2. To treat consumers and personal care workers with dignity and respect.

3. To provide the personal care workers with written instructions of services needed, their protocols, and any protective equipment needed.

4. To be a certified, approved provider and to be reimbursed only for covered services if the consumer is eligible on the date of service.

5. To comply with all state and federal requirements.

6. To verify that services assigned are appropriate and medically necessary.

7. To prepare and maintain all records concerning the nature and scope of services provided.

8. To be an equal opportunity employer in compliance with all civil rights and non-discrimination laws.

9. To provide the training necessary for personal care workers.

10. To place and/or terminate personal care workers based upon the health and safety needs stated in the consumer's plan of care or due to violations of Independence*First's* policies or rules of conduct.

11. To apply for prior authorization as needed by the consumer.

12. To formally evaluate and supervise, with the consumer's input, the performance of the personal care worker.

13. To determine wages, benefits and fees for services.

14. To require each consumer to sign a written service agreement.

15. To secure reimbursement for certified services provided by the personal care workers and personal care coordinators/RNs.

16. To limit or terminate consumers from the program who refuse or fail to present a valid, current Medical Assistance card on application and every month thereafter or who abuse or misuse the plan of care services.

17. To determine the number of home visits necessary to provide appropriate care to the consumer (a minimum of every 60 days as per Medical Assistance Personal Care Program requirements).

18. To follow all professional standards and care protocols established for the consumer.

Photographers &Writers

LILA ARYAN

Aryan is a commercial and fine art photographer. She is a 1990 graduate of the Milwaukee Institute of Art & Design with a Bachelor's degree in Fine Art-Photography. For 16 years she has owned her own commercial photography business as an independent contractor and exhibited her fine art work in local galleries. Aryan volunteers her time and art to Arab World Fest, the AIDS Resource Center of Wisconsin, Eastbrook Church Drama Ministries and the Milwaukee Institute of Art & Design.

FRANCIS FORD

Ford has been a photojournalist and editorial and commercial photographer in Milwaukee for the past 35 years. Ford was the Picture Editor of Art Muscle Magazine from 1986-1997. He has been teaching photography at the Milwaukee Institute of Art & Design from 1992 to the present. Ford has had many photography exhibits in New York, Minneapolis, Chicago and Milwaukee. His main focus has always been portraiture. Ford has photographed the famous and the not so famous.

JOHN SIBILSKI

Sibilski is a people photographer, plain and simple. You can find his images in magazines, advertising, corporate reports and, of course, books. His involvement in this project was motivated by his deep respect for those who give themselves unselfishly to others. Sibilski lives in Wisconsin with his wife Stacey, an occupational therapist, and their three children.

TOM OLIN

Olin has covered the disability rights beat since 1983. He covers the national activism of ADAPT and Not Dead Yet. He photographs conferences of the National Council of Independent Living, of TASH, and of statewide independent living councils. Thanks to his photography, many of our finest activists will not be forgotten. Currently, he is archiving his work for the Smithsonian. Contact him at: crippower@aol.com.

JOHN HUGHES

Hughes is an Episcopal clergyman who has been published in the Milwaukee Journal Sentinel as well as in Milwaukee, Vital Source and Christianity Today magazines. Author of the self-published book "Broken Winged Flights," he lives with the younger of his two daughters in Milwaukee, Wisconsin.

MARY-LIZ SHAW

Shaw has been a journalist for nearly 20 years, covering a range of beats for newspapers and magazines in the Northeast, the Midwest and in Canada. She has worked for the Milwaukee Journal Sentinel since 2001, where she writes entertainment features and reviews and edits a weekly entertainment calendar.

CROCKER STEPHENSON

Stephenson, who lives in Milwaukee with his three children, is a staff writer for the Milwaukee Journal Sentinel.

ACKNOWLEDGMENTS

We would like to acknowledge the following people for their support in making *A Celebration of Caregiving* possible.

Anna Dobrakowska, whose outstanding caregiving for Lillian Cohen inspired this book.

Barbara Markoff, for the book idea and her role as project manager.

Independence*First* staff – Lee Schulz, Scott Luber, Carol Voss, and Jamakaya – for the expertise and dedication that fueled the book from the initial idea through final production.

Joe Hausch from Hausch Design Agency LLC, for creative direction, book design and production.

Mary McCarthy, formerly with Harry W. Schwartz Bookshops, for her ongoing advice and support for the book.

Cathy Markoff from McGraw Hill and Mary Marcdante, for their expertise on marketing the book.

Keith and Kathy Spore, for their creative suggestions.

Wendy Mathison, for allowing us to use her journal entry in the book.

Valerie Stefanich from Stowell Associates, Select Staff, Inc., for contributing story ideas.

A special thanks to the Greater Milwaukee Foundation's Eugene Hayman Independence*First* Fund for its support of this project.

For additional story referrals we thank: Joe Shapiro of National Public Radio, James C. Svehla of the Naperville Sun, Ginger Reimer and staff at Independence*First*, Dr. Bruce Himmelstein, Pat Bruce of the Family Caregiver Support Network, Dr. William Elliott, Susan Duvall of the Milwaukee Aging Consortium, Connie Siskowski of the American Association of Caregiving Youth, Patsy J. Delgado of the Indian Council of the Elderly, Inc., Nelva Olin of the United Community Center Adult Day Center.